IMAGES
of Rail

NEW HAVEN STREETCARS

Larry,
Happy Birthday ... and
relive your early youth.

Vagrant

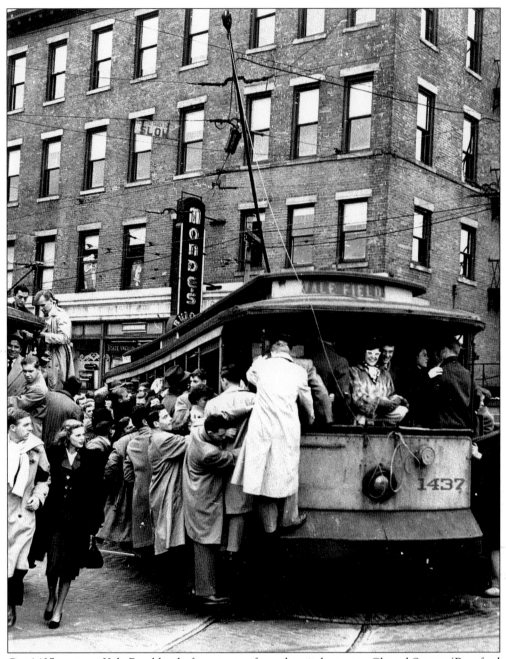

Car 1437 carries a Yale Bowl load of passengers from the viaduct onto Chapel Street. (Branford Electric Railway Association collection.)

IMAGES
of Rail

New Haven Streetcars

Branford Electric Railway Association

ARCADIA

First printed in 2003.
Reprinted in 2003.

Published by Arcadia Publishing,
an imprint of Tempus Publishing Inc.
2A Cumberland Street
Charleston, SC 29401

Printed in Great Britain.

Library of Congress Catalog Card Number: 2003104551

For all general information, contact Arcadia Publishing:
Telephone 843-853-2070
Fax 843-853-0044
E-mail sales@arcadiapublishing.com

For customer service and orders:
Toll-free 1-888-313-2665

Visit us on the Internet at www.arcadiapublishing.com.

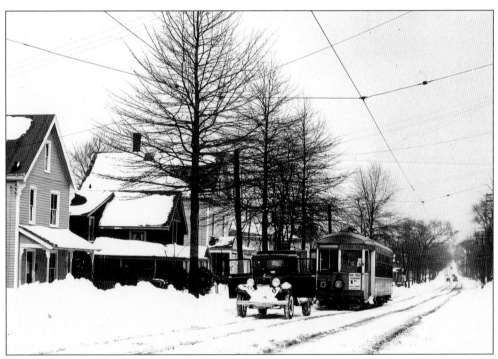

Car 3202 is northbound approaching Grannis Corner on January 25, 1935. (Charles Rufus Harte–Connecticut Company photograph, Branford Electric Railway Association collection.)

CONTENTS

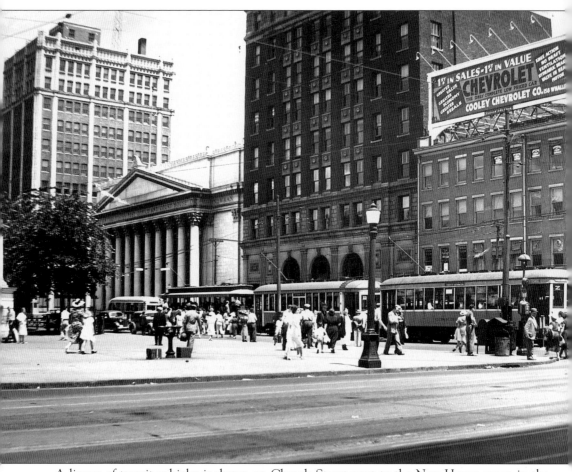

A lineup of transit vehicles is shown on Church Street next to the New Haven green in the summer *c.* 1937. (Al Gilcher photograph, George Baehr collection.)

INTRODUCTION

We would like to show you New Haven and its streetcars. For 88 years, from 1860 to 1948, the cars served the city and the surrounding towns of East Haven, Hamden, North Haven, and West Haven. This was the New Haven Division of the Connecticut Company, which also included two lines extending into Branford and Wallingford.

The photographs in this book are laid out along New Haven's car lines. You will start in downtown, head south to the railroad station, and proceed clockwise around the city. The 1923 version of the Connecticut Company's official track mileage map is included to guide you on your journey. This edition of the map shows the system at its greatest extent, but it can be used as a reference only for that year, as track changes were continually being made. Major modifications made after that date have been added as insets.

The street railways did not serve just these places. They served the people who lived, worked, and visited there. Most of the pictures included in this book show the people, buildings, clothes, automobiles, and other features of daily life at the time the photograph was taken. We also hope to show some of the changes that took place in these communities over the years.

Having stated our intent for this book, we should also tell you what we are not trying to do. It is impossible to present a meaningful history of trolley lines without examining the history of the towns through which they ran, so we are not preparing a chronology of the local streetcar operation. Neither have we prepared a roster of the street railway equipment used in the area. Facts about the cars, neighborhood, structure, or company shown will be included in the captions. The authors realize that some readers may desire more information than could be include on 128 pages. We would be pleased to provide any data available if you contact us at the Shore Line Trolley Museum, 17 River Street, East Haven, Connecticut, 06512. Meanwhile, enjoy your trolley tour.

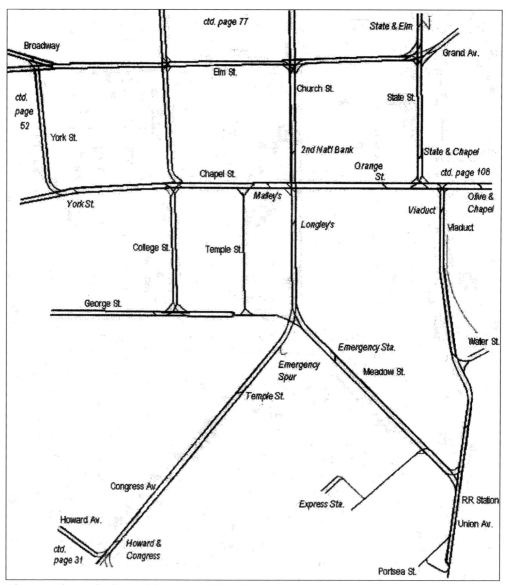

This map shows the lines of downtown New Haven.

One

DOWNTOWN

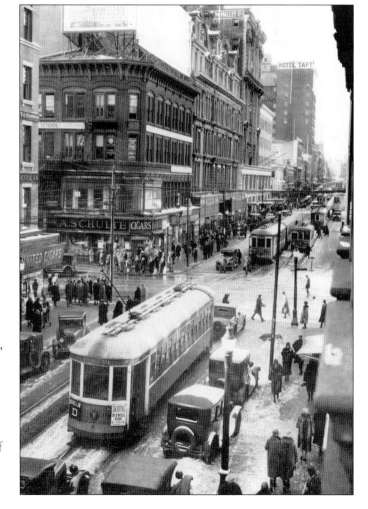

The center of the Connecticut Company's trolley operation in New Haven was at the downtown intersection of Church and Chapel Streets. All cars passed by on one of these two streets, and track mileage on the New Haven Division was calculated from this point. Looking west on Chapel, we can see five streetcars; there are undoubtedly another five or more out of sight on Church Street. (Branford Electric Railway Association collection.)

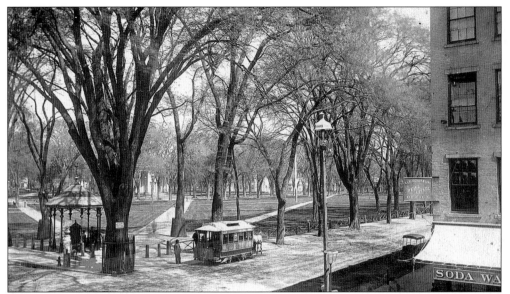

New Haven's 17-acre town green, which was the central square of the town's original nine-square layout, was used as a burying ground and drill field for the militia in the 17th century. At one time, there were six buildings on the town green. The last of these structures was removed in 1849, and the view beyond the Dixwell Avenue horsecar does not look very different from this 1880s scene. (Branford Electric Railway Association collection.)

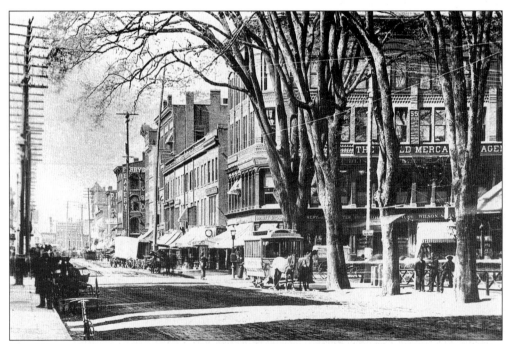

New Haven and Centreville Horse Railway 3 waits on Church Street at Chapel Street next to the elm trees bordering the New Haven green before embarking on a trip up Dixwell and Shelton Avenues. A century earlier, Rep. James Hillhouse (1754–1832) promoted the planting of the trees that gave New Haven the nickname Elm City. (Branford Electric Railway Association collection.)

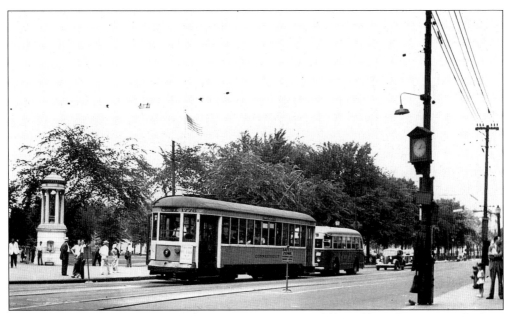

Car 1776, on a Canner Street–Washington Avenue run, is followed by a Connecticut Railway and Lighting Company bus from Waterbury on a summer afternoon in 1937. The round, columned structure on the left is the Bennett drinking fountain, installed in 1907 to replace a well dug on the green in 1813. The well and pump were removed in 1913. (Al Gilcher photograph, George Baehr collection.)

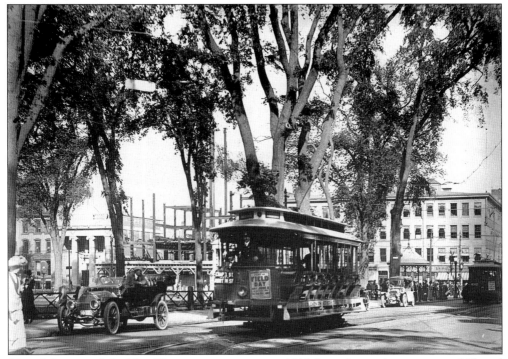

Chapel Street and the New Haven green are seen *c.* 1911 from the southeast corner of Chapel and Temple Streets. (Branford Electric Railway Association collection.)

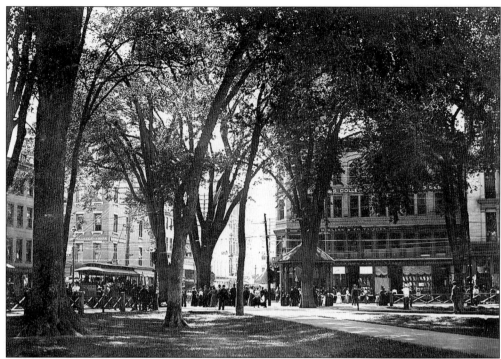

Car 283, built by J.M. Jones in 1895, is shown here framed by the elm trees on the southeast corner of the New Haven green. (Branford Electric Railway Association collection.)

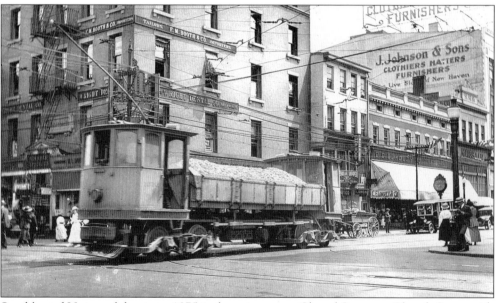

Southbound Universal dump car 1075 is clattering across Chapel Street on Church Street with a load of ballast on June 17, 1918. (Charles Rufus Harte–Connecticut Company photograph, Branford Electric Railway Association collection.)

One of the cars built by Jewett in 1904 is shown here on Chapel Street, moving sedately past the New Haven green and its c. 1846 cast-iron fence. A New Haven city ordinance limited traffic to a maximum speed of 10 miles per hour within a mile of city hall on Church Street opposite the green and 12 miles per hour beyond the mile radius. (Branford Electric Railway Association collection.)

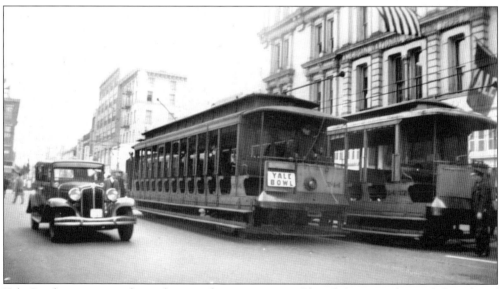

Yale Bowl trippers are shown here at the crossover on Chapel Street in front of the Edward Malley Company, New Haven's largest department store, on November 1, 1941. (John H. Koella photograph.)

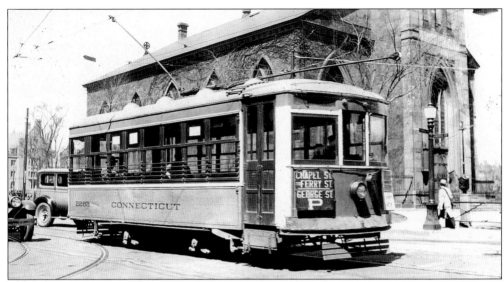

Safety car 2282, built by the American Car Company of St. Louis, Missouri, in 1918, passes Trinity Church at Chapel and Temple Streets on April 8, 1931. (Charles Rufus Harte–Connecticut Company photograph, Branford Electric Railway Association collection.)

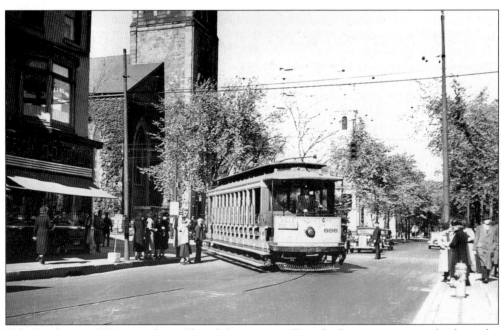

Yale Bowl extra 656 turns from Chapel Street onto Temple Street on its way back to the railroad station on Saturday, October 16, 1937. (Charles Duncan photograph, Branford Electric Railway Association collection.)

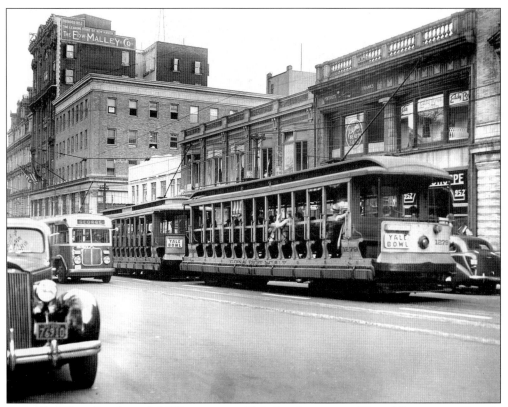

A small Yellow Coach model 712 passes two Yale Bowl extras on Chapel Street near Temple Street in October 1944. (Al Gilcher photograph, George Baehr collection.)

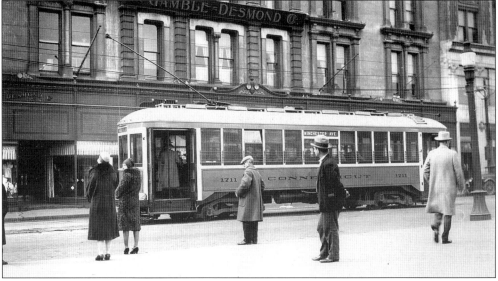

The man inside the car at the fare box on the rear platform indicates that car 1711 is still staffed by a motorman and conductor on Monday, November 14, 1927. Gamble Desmond (seen behind the car), on Chapel Street, was New Haven's second largest department store. (Branford Electric Railway Association collection.)

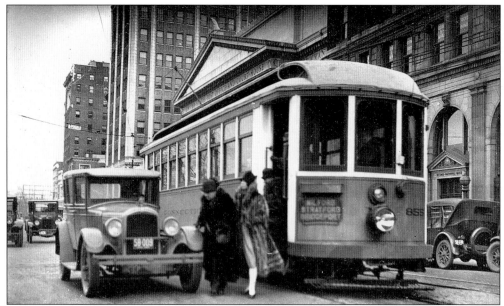

Automobile traffic waits for passengers to disembark from car 855 on Church Street at the New Haven green. By the time this picture was taken—probably in the late 1920s—steel cars in the 1900 series held down most of the longer suburban runs like New Haven–Bridgeport. Car 855 may be a rush-hour tripper or a substitute car filling in for a 1900 in the shop. (Branford Electric Railway Association collection.)

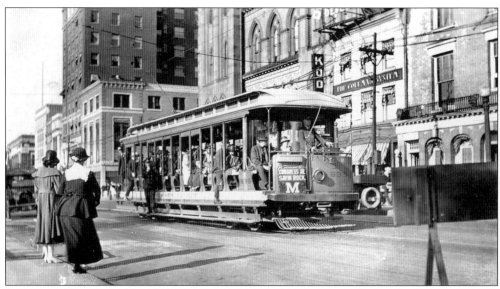

Open car 835 stops on Church Street at the New Haven green on Saturday, June 15, 1918, with a full load of passengers headed for the amusement park at Savin Rock. (Charles Rufus Harte–Connecticut Company photograph, Branford Electric Railway Association collection.)

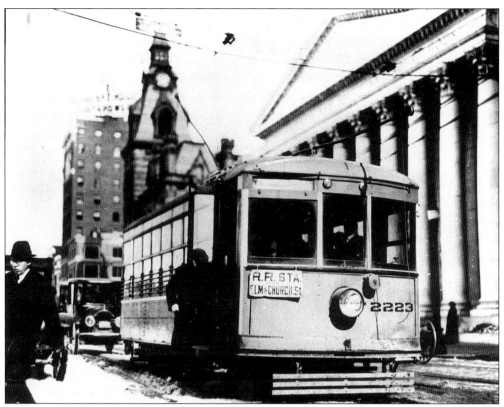

Safety car 2223 was built by the American Car Company of St. Louis, Missouri, in 1918. It is shown here in the early 1920s on a rush-hour shuttle run linking downtown with the railroad station. (George Baehr collection.)

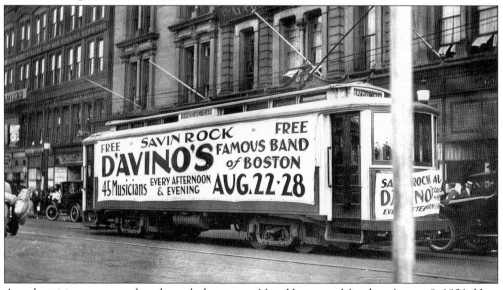

An advertising car meanders through downtown New Haven on Monday, August 8, 1921. How much did it cost to pay 45 musicians for an entire week? (Charles Rufus Harte–Connecticut Company photograph, Branford Electric Railway Association collection.)

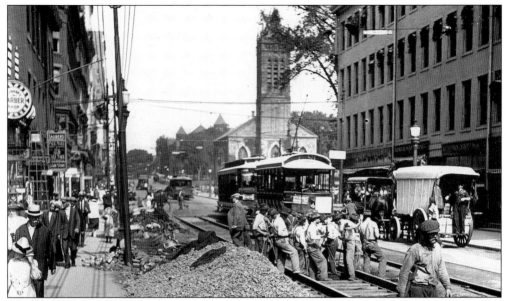

New Haven's commercial center was on Chapel Street between Church and State Streets. The track work shown is being done on Chapel Street at Church Street in 1913. On the right, next to the wagon, is the still extant Greek Revival Exchange Building of 1832. (New Haven Colony Historical Society collection.)

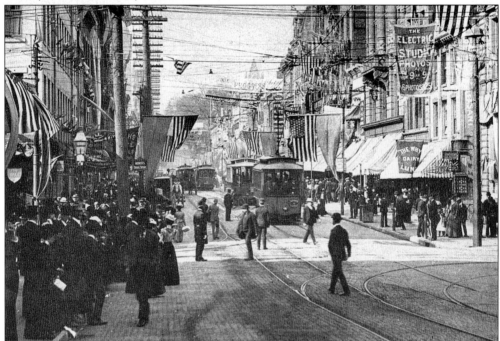

The flags and crowd on Chapel Street between Church and State Streets in 1901 suggest that it might be time for one of the year's major civic events—the Fourth of July parade. On the other hand, there is not a single open car in sight, so it is probably not July. Election Day was a major event a century ago, but there are no campaign posters. (Branford Electric Railway Association collection.)

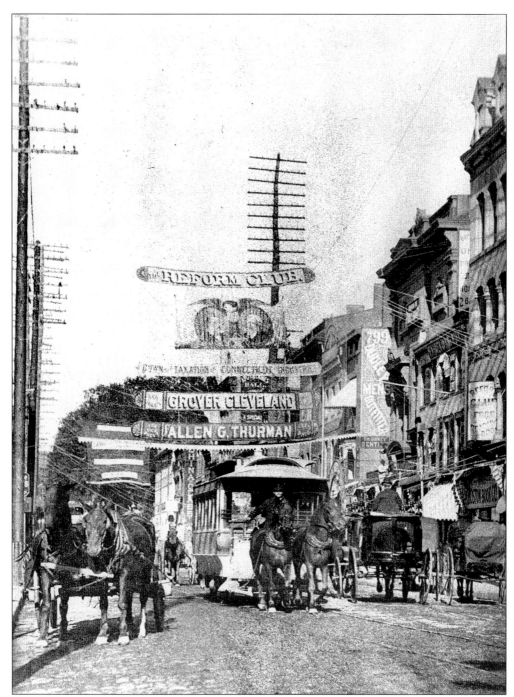

Chapel and State Streets are shown here in the autumn of 1888. Benjamin Harrison and Levi Morton won the November election, and Thurman never served as vice president. Cleveland served as president from 1885 to 1889 and was elected again in 1892. By the time Cleveland was sworn in the following March, the horsecars, which reached this intersection on the afternoon of Wednesday, May 1, 1861, were being replaced by trolleys. (Branford Electric Railway Association collection.)

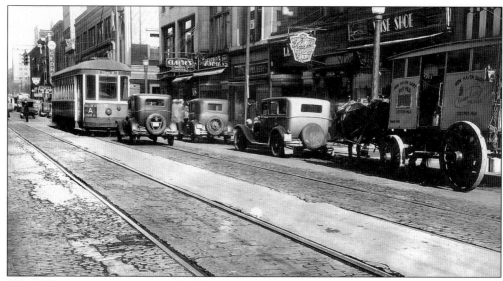

Chapel Street is seen in a view looking west to the intersection of Orange Street on Friday, March 25, 1932. There is not much activity going on, as nearly 25 percent of New Haven's labor force is unemployed and the city itself is approaching bankruptcy. (Branford Electric Railway Association collection.)

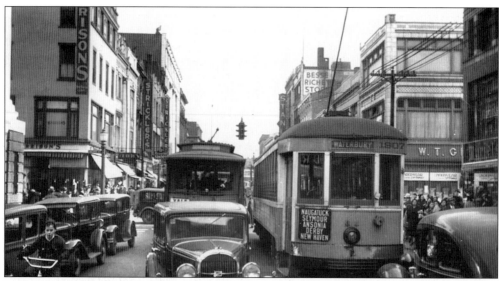

When the New York, New Haven & Hartford Railroad and its subsidiaries entered bankruptcy, the Connecticut Railway and Lighting trolley lines leased to the Connecticut Company in 1906 were returned to Connecticut Railway and Lighting. Both companies assigned cars (later buses) to the jointly operated lines between New Haven and Bridgeport, Waterbury via Derby, and Waterbury via Cheshire. (Branford Electric Railway Association collection.)

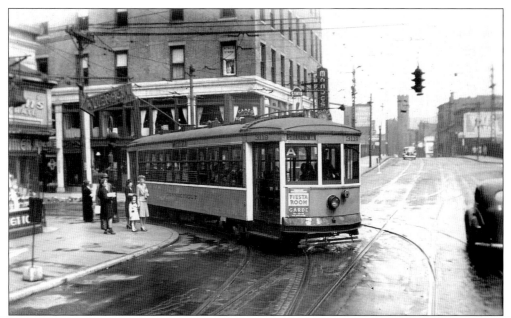

Car 3119 turns from State Street onto Chapel Street on Sunday, May 17, 1946. The car was built in 1923 by the Osgood Bradley Car Company of Worcester, Massachusetts, and was scrapped in July 1948. (Jack Beers photograph, George Baehr collection.)

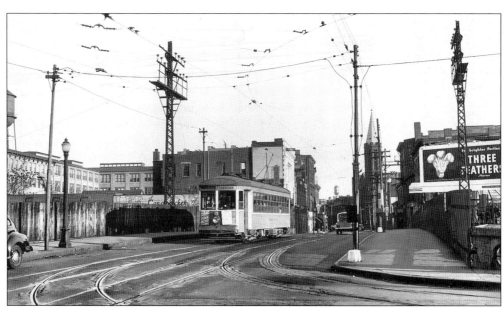

Westbound 3208 on Chapel Street passes over the New York, New Haven & Hartford Railroad cut east of State Street in November 1946. The tracks in the foreground curve onto the Connecticut Company's trolley viaduct. (Branford Electric Railway Association collection.)

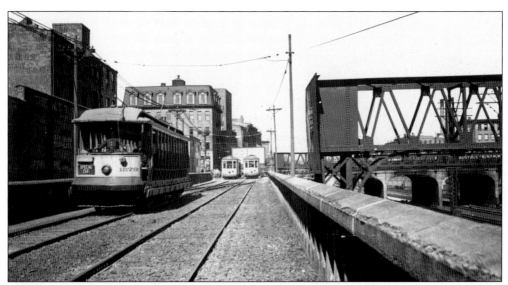

Open car 1279 is southbound on the trolley viaduct next to the New York, New Haven & Hartford cut just east of State Street. The car is at the crossover just south of Chapel Street in August 1941. (Branford Electric Railway Association collection.)

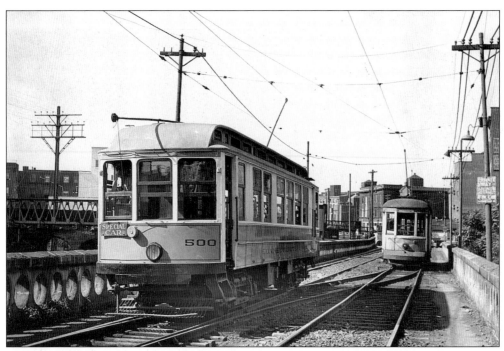

Parlor car 500 is northbound on the viaduct at the crossover just south of Chapel Street. The viaduct was built in 1909 to replace a section of congested single track on State Street. (Branford Electric Railway Association collection.)

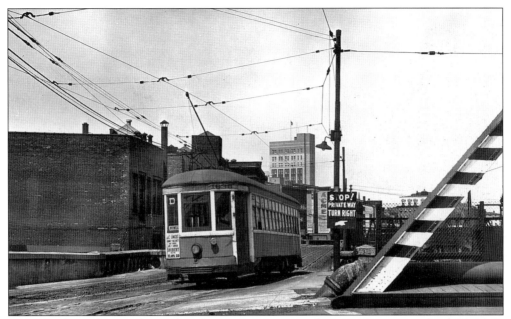

A car heads north onto the viaduct from Water Street and Union Avenue on April 27, 1947. (John H. Koella photograph.)

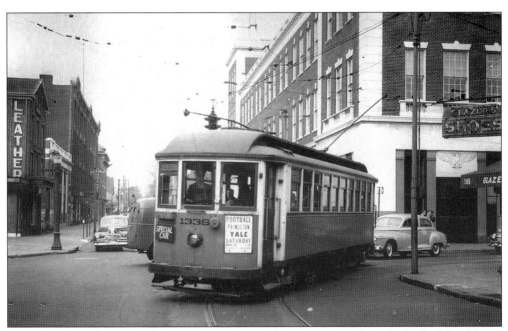

Car 1339 turns from Temple Street onto George Street in November 1946. The New Haven Colony's first Puritan settlers landed here on the north bank of West Creek in 1638 and established their town on the coastal plain surrounded by rocky ridges. (George Baehr collection.)

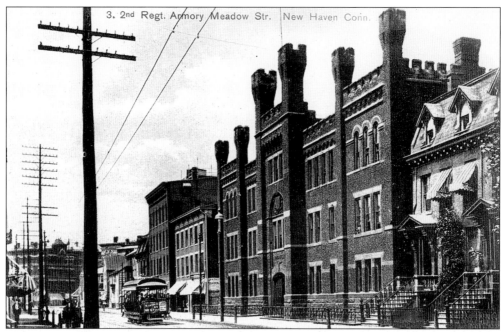

One of the original open cars of 1893 passes the armory on Meadow Street in 1905. Meadow Street was the colonial path that ran from the original settlement or lower town at George Street to the harbor at Water Street. (Branford Electric Railway Association collection.)

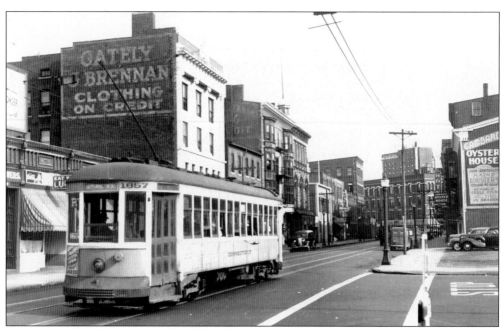

Car 1857 heads up Meadow Street from the railroad station toward Congress Square. (Tom McNamara photograph, George Baehr collection.)

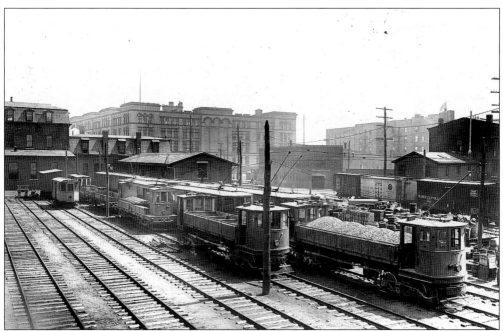

The Trolley Express Company was created in 1905 to handle the Consolidated Railway's freight business. In 1907, it became the Connecticut Company Express Department, headquartered in the old New Haven and Derby Railroad depot on Meadow Street. Express cars traveled on a regular schedule to 57 freight stations throughout Connecticut. Express service lasted until improved roads and motor vehicles made it more economical to ship goods by truck. (Branford Electric Railway Association collection.)

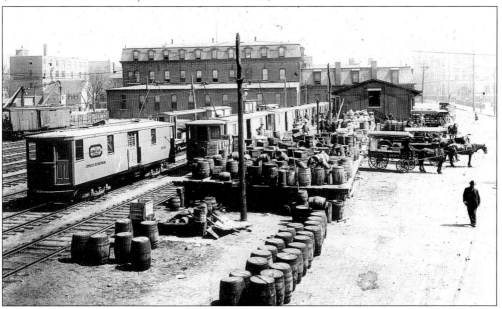

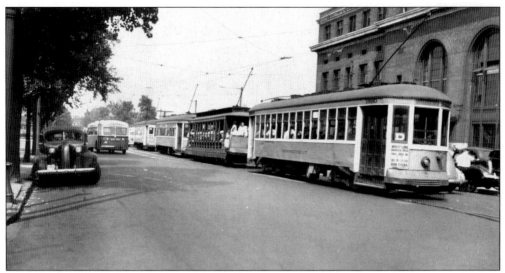
A lineup of cars, shown in front of the railroad station in July 1942, is passed by a 1937 Twin Coach. (Roger Somers photograph, George Baehr collection.)

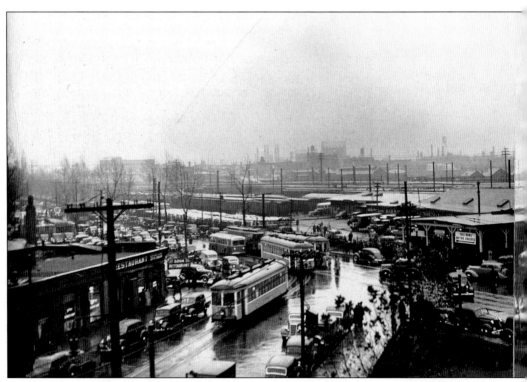
Some of the vehicles needed to handle the crowd for the Yale-Princeton football game on Saturday, November 13, 1937, wait at the New Haven railroad station for the arrival of the

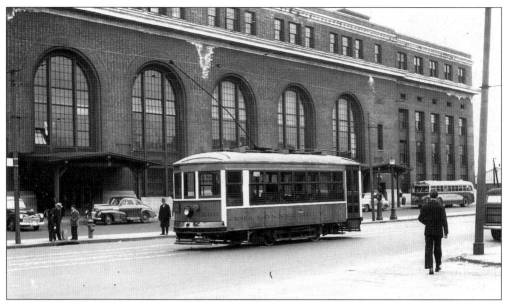

Safety car 2350 poses for the camera in front of the New Haven Union Railroad station on January 19, 1947. The refurbished 1918 station, designed by Cass Gilbert, still serves rail passengers, and the refurbished 2350 still poses for cameras at the Shore Line Trolley Museum in Branford, Connecticut. (Jack Beers photograph, George Baehr collection.)

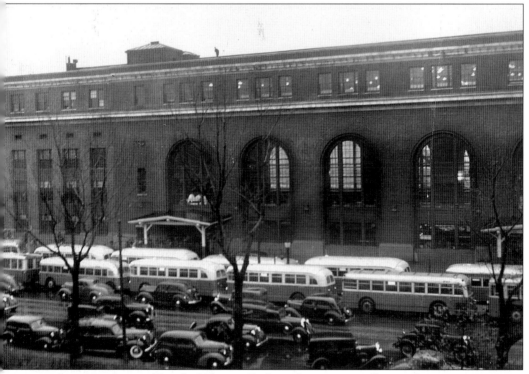

train from New Jersey. (Branford Electric Railway Association collection.)

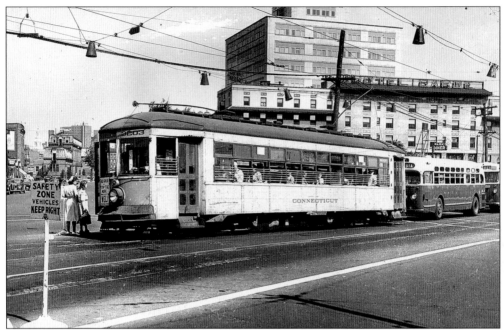

Two young ladies prepare to board West Haven–bound 3203 for what may be a final ride on a trolley. The photograph is undated, but we know it is very close to the end of streetcar service in New Haven, as the bus behind the car is a brand-new 1948 General Motors model TDH-3610. Behind the GM bus is a Mack of 1941 vintage. Streetcars made their final run in the early-morning hours of September 26, 1948. (Jack Beers photograph, George Baehr collection.)

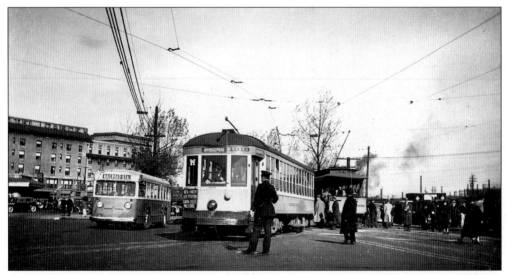

Car 1919 is shown passing the New Haven railroad station en route to West Haven, Milford, and Bridgeport on Saturday, October 31, 1936. The open car and Yellow Coach are in Yale Bowl service. (Charles Duncan photograph, Branford Electric Railway Association collection.)

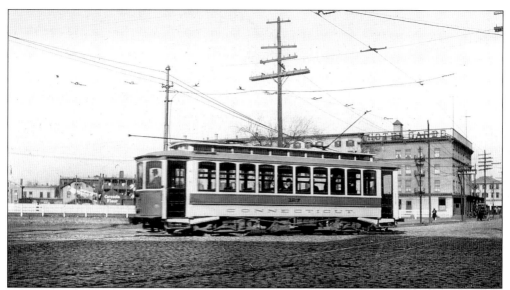

One of six cars built by the J.G. Brill Company in 1900 for the Fair Haven and Westville Railroad turns from Union Avenue onto Portsea Street on November 23, 1910. In the 1915 system-wide renumbering, car 127 became 584 and was transferred to the isolated Torrington-Winsted line, where it remained until trolley service ended there in January 1929. (Charles Rufus Harte–Connecticut Company photograph, Branford Electric Railway Association collection.)

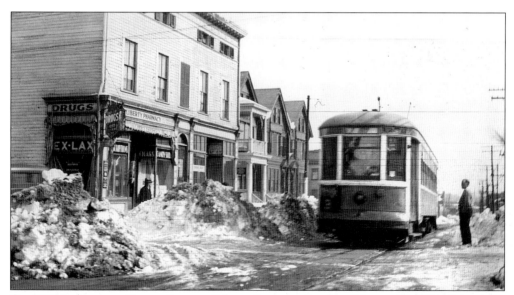

Car 1738 is shown on Portsea Street at Liberty Street on Sunday, February 25, 1934. Behind the camera is a neighborhood known in the 19th century as Pleasant Hill (later referred to as the Hill). Like New Haven, the site was laid out as a nine-square plot with the central square—Trowbridge Square—reserved as an open green space. (Branford Electric Railway Association collection.)

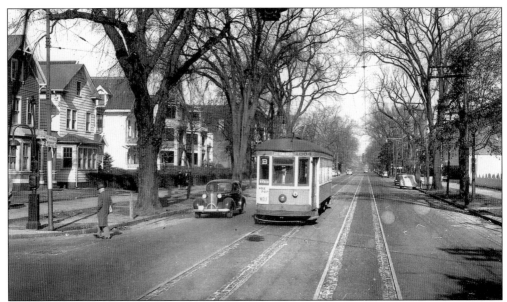

Car 1884 is seen here on Howard Avenue on November 9, 1947. Howard Avenue ran down the spine of a two-block-wide promontory situated between the New Haven harbor and the wetlands at the mouth of the West River. Extensive landfill projects have obliterated the natural landscape. (Jack Beers photograph, George Baehr collection.)

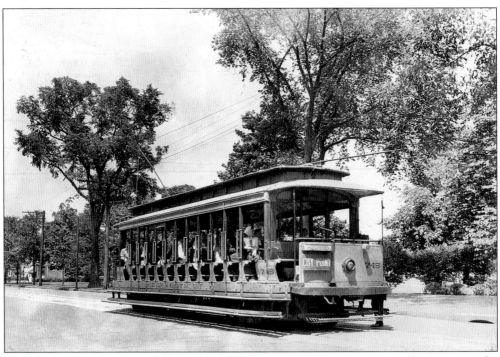

Open 745, a 1904 product of the J.G. Brill Company, is pictured on Howard Avenue in the City Point section of New Haven. The neighborhood was originally the village of Oyster Point, and the principal occupation of its residents was harvesting oysters. (Al Gilcher photograph, Branford Electric Railway Association collection.)

Two

LINES SOUTHWEST

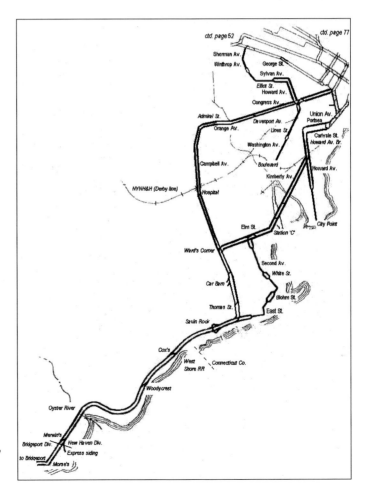

ctd. page 52
ctd. page 77

The southwest lines
included City Point,
Second Avenue, Savin
Rock, Bridgeport, Dawson
Avenue, Congress Avenue,
Washington Avenue, and
Sylvan Avenue.

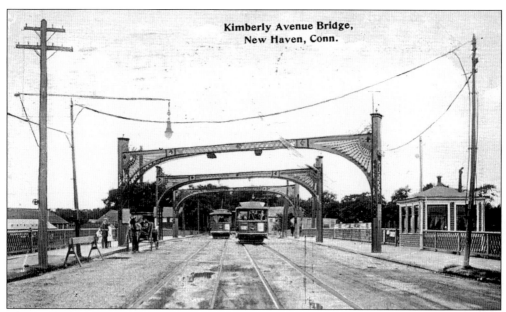

The Kimberly Avenue bridge was first used by the cars of the New Haven and West Haven Horse Railroad. Streetcars continued to use the bridge until the end of trolley service in September 1948. (Branford Electric Railway Association collection.)

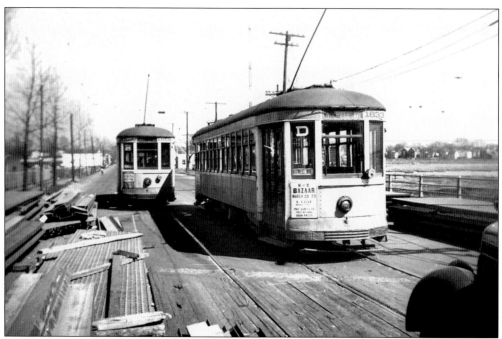

Repair work on the Kimberly Avenue bridge in March 1946 forced the streetcars to temporarily terminate at either end of the span. Passengers walked across the bridge and boarded another car to continue their trip. (Jack Beers photograph, George Baehr collection.)

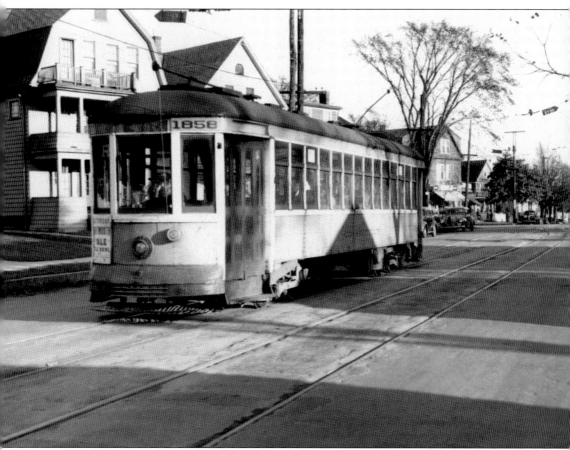

Car 1858 is at the turnout on Second Avenue between White and Brown Streets on Saturday, November 8, 1947, one week before the line was converted to bus service. (Jack Beers photograph, George Baehr collection.)

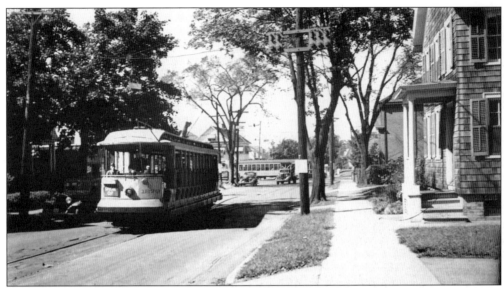

Westbound open 1279 is shown at the end of the double track on Second Avenue in West Haven. At the corner, a car passes on Elm Street. (Charles Duncan photograph, Branford Electric Railway Association collection.)

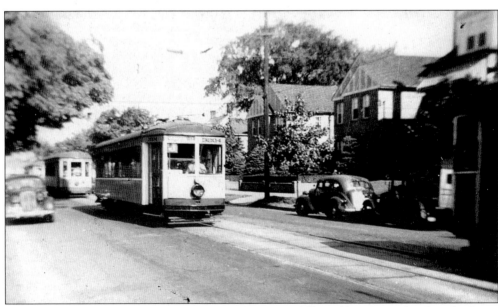

A Dawson Avenue–bound J car rolls down Elm Street, followed by a D car heading for Savin Rock on Tuesday, September 29, 1942. (Branford Electric Railway Association collection.)

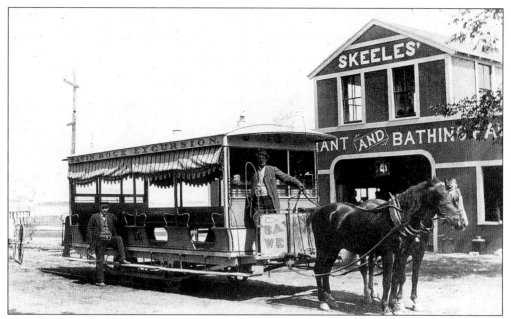

New Haven and West Haven Horse Railroad car 10 is shown on Beach Street in West Haven. By 1867, horsecars connected the center of both towns and were soon extended another mile to the shore of Long Island Sound. In 1870, some of the attractions at Savin Rock were beer gardens, a baseball park, cockfights, a 1,500-foot pier, horse racing, and prize fights. The area was popular enough to warrant year-round direct ferry service from the lighthouse in East Haven. (Branford Electric Railway Association collection.)

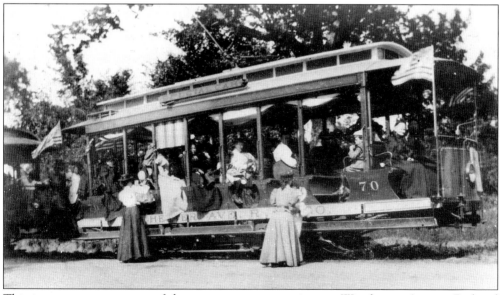

This image captures a turn-of-the-century summer outing on Winchester Avenue Railroad car 70. The location is probably Savin Rock, as the New Haven and West Haven Horse Railroad serving that amusement area was absorbed by the Winchester in 1893. The American flags on the cars suggest that it is around the Fourth of July. (Branford Electric Railway Association collection.)

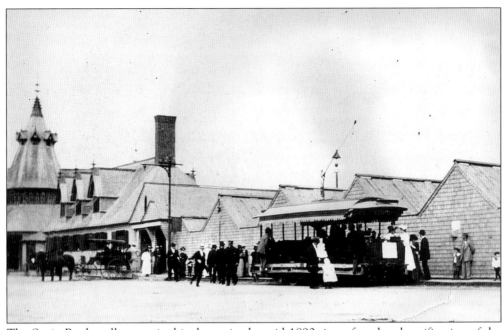

The Savin Rock trolley terminal is shown in the mid-1890s just after the electrification of the line from New Haven to West Haven. (Branford Electric Railway Association collection.)

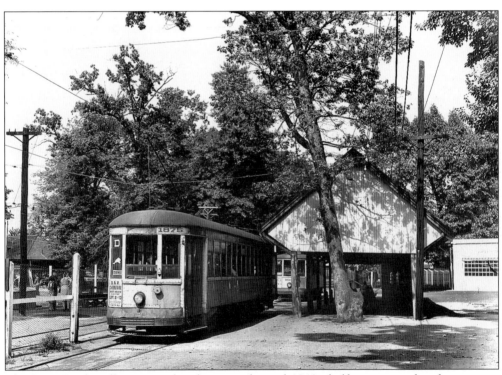

The Savin Rock trolley terminal is shown in the mid-1940s, half a century after the previous photograph was taken. (Branford Electric Railway Association collection.)

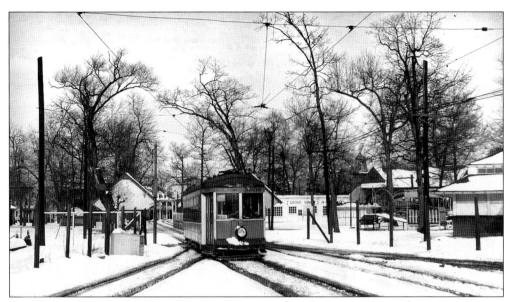

Seen is car 3206 heading for Dawson Avenue on the J line at Savin Rock in West Haven. Twelve of these cars were built in 1926 by the Osgood Bradley Car Company of Worcester, Massachusetts, for the Berkshire Street Railway. In the winter of 1931–1932, when the Berkshire stopped running streetcars, the 12 cars were transferred to the Connecticut Company. Both trolley systems were owned by the New York, New Haven & Hartford Railroad. (Branford Electric Railway Association collection.)

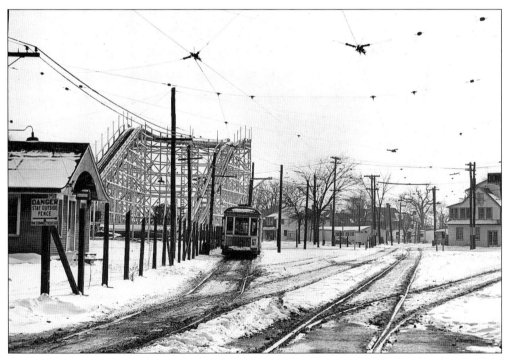

A Dixwell Avenue car waits on the Savin Rock loop in February 1947 before heading back to New Haven and Hamden. (Kent Cockrane photograph, George Baehr collection.)

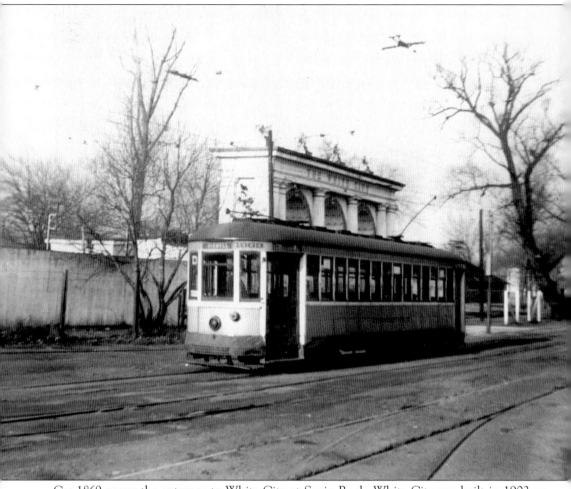

Car 1869 passes the entrance to White City at Savin Rock. White City was built in 1902 on the site of West Haven's 1870 baseball grounds. A new ballpark was constructed a short distance away at Oak Street and Savin Avenue. (John H. Koella photograph.)

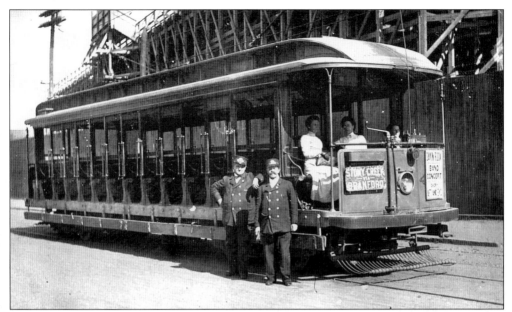

Conductor Charles Minnix (left), motorman Charles Morris, and two unidentified women pose next to the ballpark at Savin Rock. Direct service between Savin Rock, Branford, and many other places on the Connecticut Company system was offered before World War I. (Branford Electric Railway Association collection.)

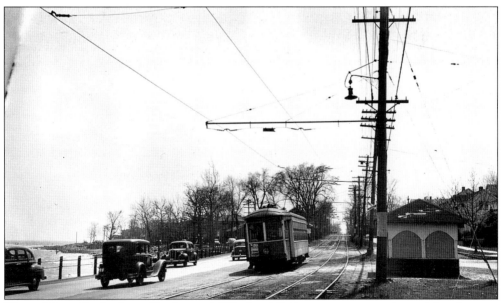

West of Savin Rock, the trolley line to Milford and Bridgeport ran on a private right-of-way to the north of Ocean Avenue. Car 3204 is shown here traveling eastbound on Sunday, April 27, 1947. (Branford Electric Railway Association collection.)

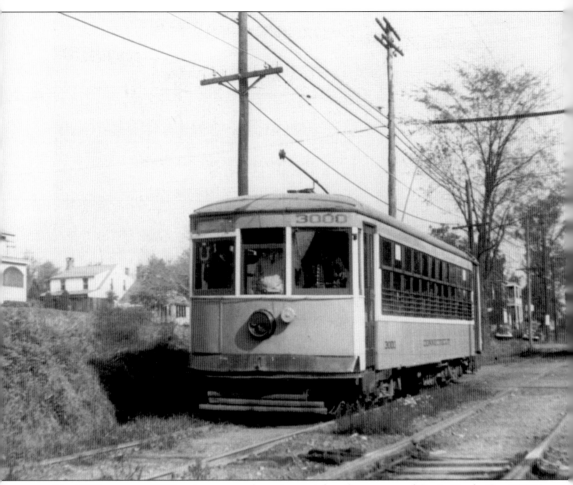

Car 3000 passes a 3200-series car on the private right-of-way west of Savin Rock. Car 3000 is one of three safety cars built in 1922 by the Wason Car Manufacturing Company of Springfield, Massachusetts, for use on the Torrington–Winsted line. The car was shipped to New Haven in 1929, when that line was abandoned. (John H. Koella photograph.)

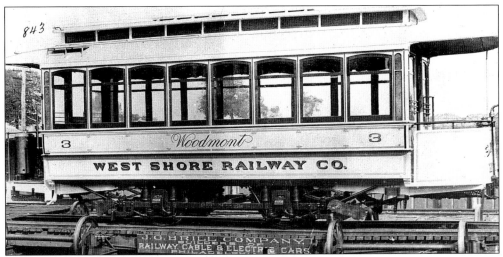

In 1893, the West Shore Railway was created to extend the line of the New Haven and West Haven Horse Railroad westward from Savin Rock to Milford. The four-and-half-mile horsecar trip to West Haven at a top speed of six miles per hour was about as far as anyone could be expected to travel, so the new four-mile line originated with the perfection of the electric railway. (Branford Electric Railway Association collection.)

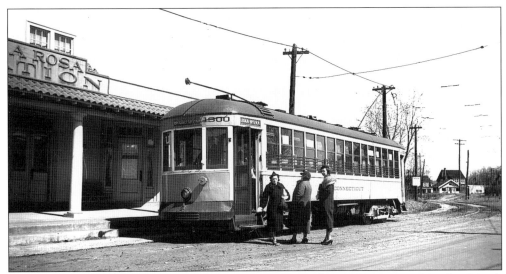

Westbound car 1900 is shown discharging three ladies at Villa Rosa Station on Monday, March 22, 1937. (Charles Duncan photograph, Branford Electric Railway Association collection.)

The private right-of-way between Savin Rock and Milford ran through backyards with a grade crossing at almost every street. Accidents on the line happened frequently, as witnessed by the many photographs in the Connecticut Company's legal files. The company's photographer took this picture at Colonial Boulevard on August 16, 1919. (Charles Rufus Harte–Connecticut Company photograph, Branford Electric Railway Association collection.)

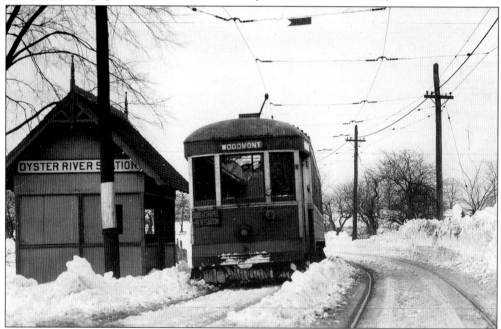

The Oyster River was established as the boundary between the towns of New Haven and Milford in 1674. Woodmont was at the boundary between the New Haven and Bridgeport Divisions of the Connecticut Company. (Charles Rufus Harte–Connecticut Company photograph, Branford Electric Railway Association collection.)

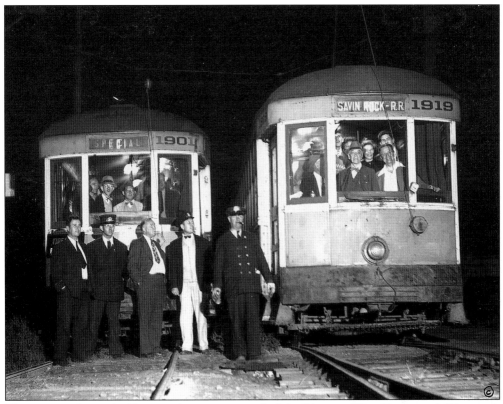

This picture shows the Dawson Avenue terminal of the J line in West Haven at 1:35 a.m. on Sunday, September 26, 1948. Car 1919 is the last regularly scheduled car on New Haven's last car line, and chartered car 1901 will follow car 1919 back to downtown New Haven and the carbarn. (John H. Koella photograph.)

A State Street car sits in front of the carbarn on Campbell Avenue in West Haven on Monday, March 22, 1937. (Charles Duncan photograph, Branford Electric Railway Association collection.)

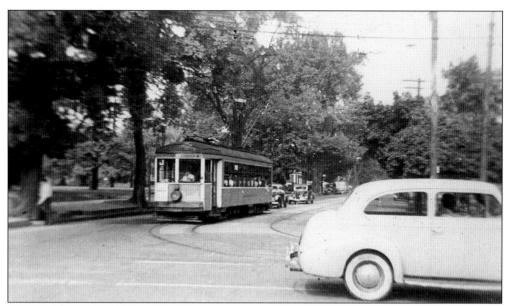

Car 3204 is shown here on Elm Street at Ward's Corner. (Henry Wheeler photograph, Branford Electric Railway Association collection.)

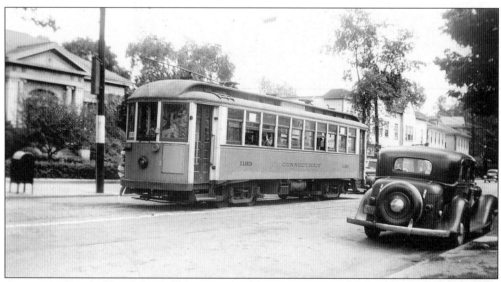

Car 1183 is pictured on Campbell Avenue at Ward's Corner. West Haven was a section of the town of Orange until a separate town was created in 1921. (Henry Wheeler photograph, Branford Electric Railway Association collection.)

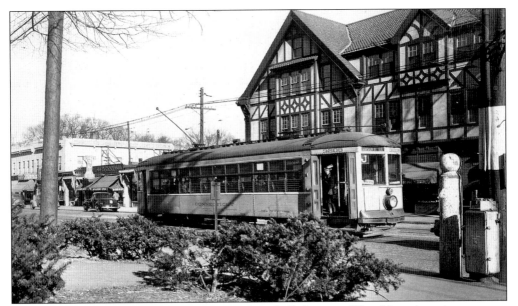

Car 3208 stops to discharge a passenger on Campbell Avenue, West Haven's main street, on Thursday, November 25, 1943. (Harry Hall photograph, Branford Electric Railway Association collection.)

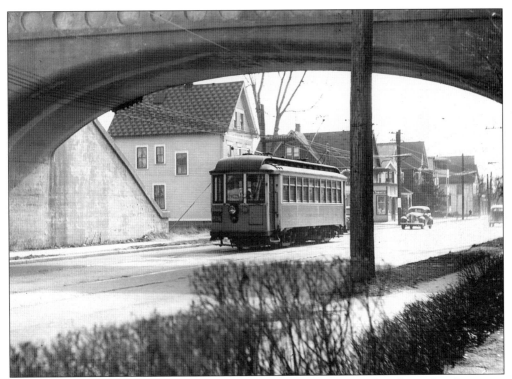

Car 861 is on Campbell Avenue, West Haven, at the New Haven and Derby Railroad overpass on Sunday, February 2, 1947. (John H. Koella photograph.)

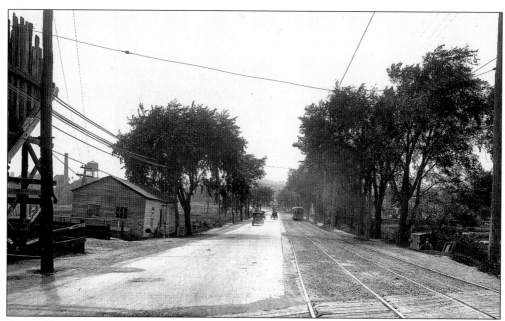

Originally, the trolley line on Orange Avenue was on a private right-of-way. Just behind the camera on July 9, 1919, is the bridge over the West River. The first bridge over this river was erected at this spot in 1639. (Branford Electric Railway Association collection.)

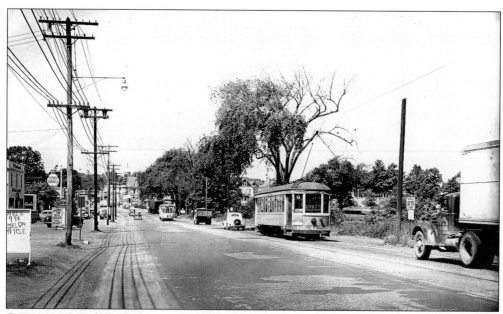

Orange Avenue (Route 1) just west of the West River bridge is shown here on Friday, July 9, 1948. When the Washington Avenue line was abandoned on May 15, 1947, O cars were extended out Congress Avenue to the Admiral Avenue switch, where an O car is turning back. The next day would see the end of streetcars on this stretch of track. (Jack Beers photograph, George Baehr collection.)

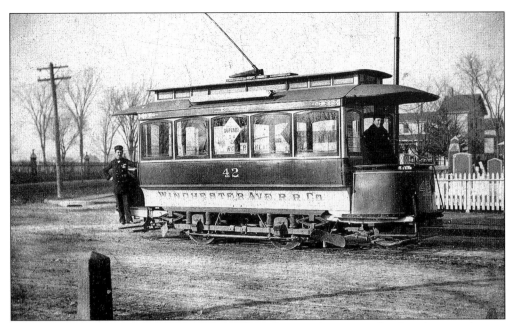

Winchester Avenue Railroad 42, on the Sylvan Avenue line, stops for the photographer on Winthrop Avenue next to Evergreen Cemetery. The line was extended north four blocks to George Street and operated as a loop through downtown. Sylvan–George was the first New Haven trolley line converted to bus operation, changing over on June 22, 1931. (Branford Electric Railway Association collection.)

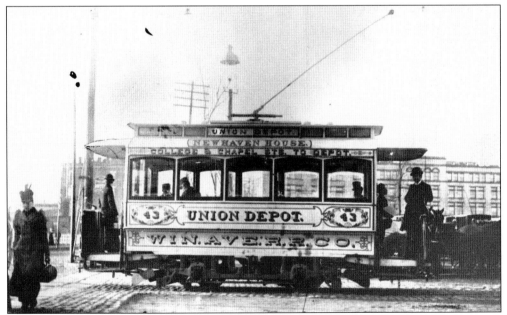

Winchester Avenue Railroad car 43 is a testimonial to the skill of the people who painted, lettered, and striped streetcars. Unfortunately, the operating companies could not afford to retain these skilled workers at $4 per day, so the cars became much plainer as they were repainted. (Branford Electric Railway Association collection.)

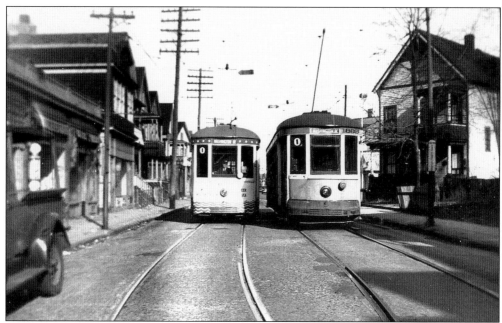

Cars 1833 and 1885 pass at the Lines Street turnout on Washington Avenue on November 29, 1943. (Jack Beers photograph, George Baehr collection.)

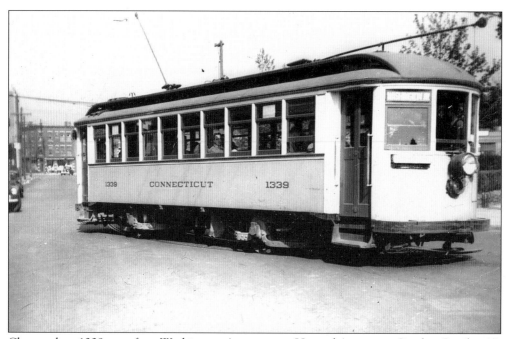

Chartered car 1339 turns from Washington Avenue onto Howard Avenue on Sunday, October 12, 1941, and heads up the block to Congress Avenue. Track was laid on Washington Avenue in 1910, the next-to-last line built in New Haven. (Branford Electric Railway Association collection.)

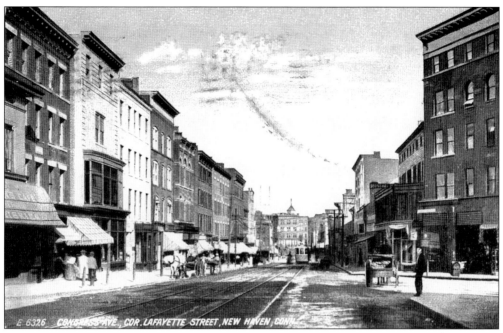

This postcard view shows Congress Avenue at Lafayette Street in the first decade of the 20th century. This neighborhood was up a steep grade above West Creek and was originally called Sodom Hill. Due to its proximity to the tanneries on Morocco (Oak) Street along the south bank of the creek and their attendant fragrance, it was already a slum in 1800. (Branford Electric Railway Association collection.)

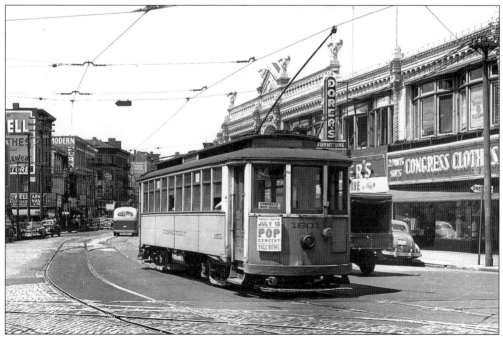

West Haven–bound car 1601 follows a ACF bus onto Congress Avenue at Congress Square. (Jack Beers photograph, George Baehr collection.)

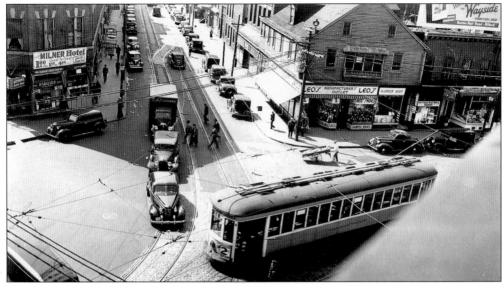

This photograph offers a typical midday view of Congress Square. The picture was taken on Saturday, May 11, 1940, from the second story of the Wood Building, on Church Street. Saturday was still a regular workday for most people in 1940, and the normal workweek was 48 hours. (Harry Hall photograph, Branford Electric Railway Association collection.)

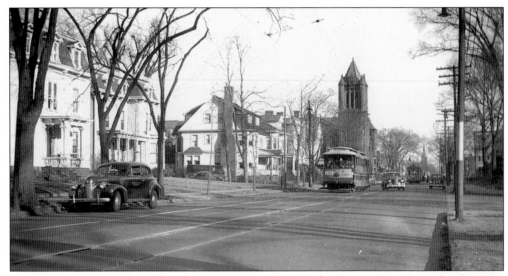

Car 1427 is westbound on Chapel Street, approaching Derby Avenue, on November 9, 1940. The tower of the Plymouth Congregational Church rises above the car. (Branford Electric Railway Association collection.)

Three

LINES WEST

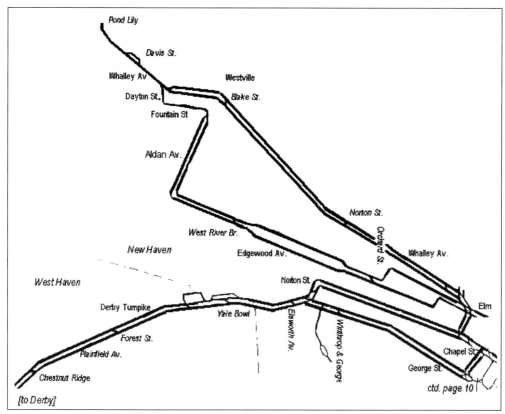

The west and northwest lines included Chapel Street, Waterbury via Derby, Edgewood Avenue, Whalley Avenue, Dixwell Avenue, and Shelton Avenue.

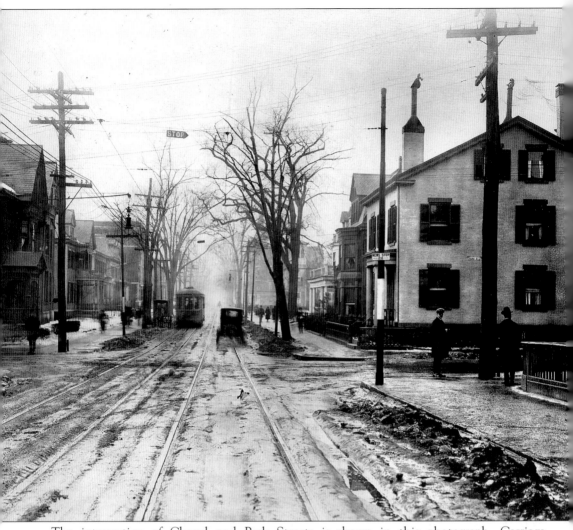

The intersection of Chapel and Park Streets is shown in this photograph. Carriage manufacturing, New Haven's largest industry in the early 19th century, was centered behind the Yale campus along Park Street. Along Chapel Street were the homes of the wealthy, while the side streets contained more modest homes. Laborers and freed slaves lived on the outskirts of the neighborhood along Samaritan (Elm) Street. (Charles Rufus Harte–Connecticut Company photograph, Branford Electric Railway Association collection.)

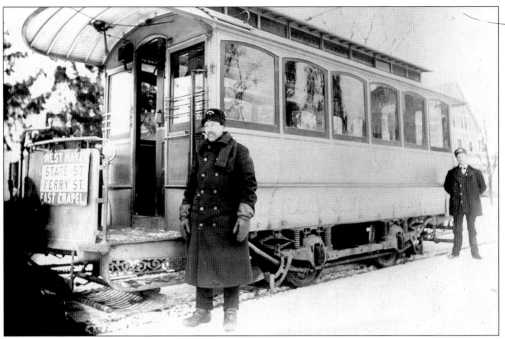

A young motorman, Henry W. Hamlin (left), and an unidentified conductor pose next to their car on a cold day before the Public Utilities Commission required the trolley company to enclose the platforms of cars used in wintertime. (Branford Electric Railway Association collection.)

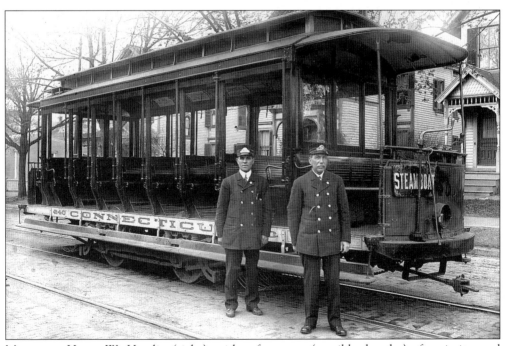

Motorman Henry W. Hamlin (right), with a few years (possibly decades) of seniority, and conductor Cornelius Fitzpatrick are posing next to their car on Norton Street between Chapel Street and Derby Avenue. (Branford Electric Railway Association collection.)

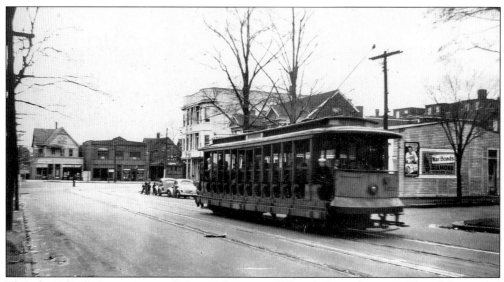

This photograph shows a view of Norton Avenue and Irving Street between Chapel Street and Derby Avenue. (Sidney Silleck Jr. photograph, Branford Electric Railway Association collection.)

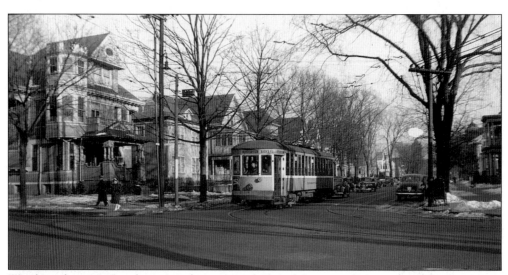

Westbound car 1915 is shown on the corner of Chapel Street and Norton Avenue in January 1942. (John H. Koella photograph.)

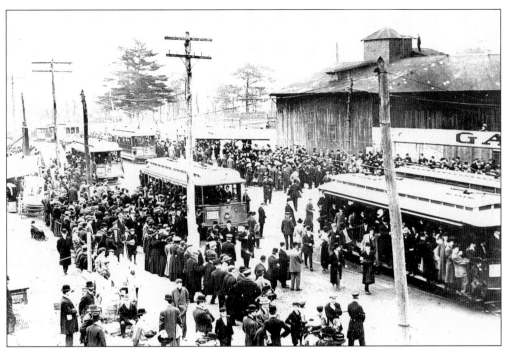

Open cars deliver football crowds to the 33,000-seat Yale Field of 1884 on the south side of Derby Turnpike in the first decade of the 20th century. In August 1913, work began on the new 70,869-seat Yale Bowl that is located on a 25-acre site on the north side of Derby Turnpike. (Branford Electric Railway Association collection.)

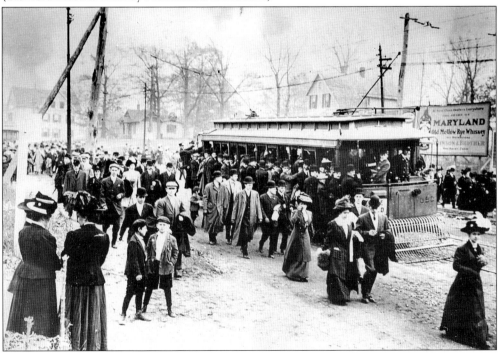

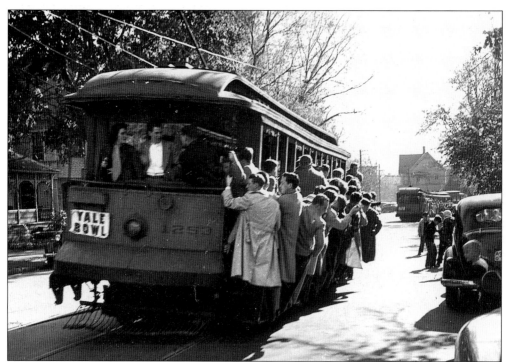

A New Haven tradition ended in November 1947, when riders to Yale Bowl stopped throwing pennies to the kids lined up along Chapel Streets and Derby Avenue. (Branford Electric Railway Association collection.)

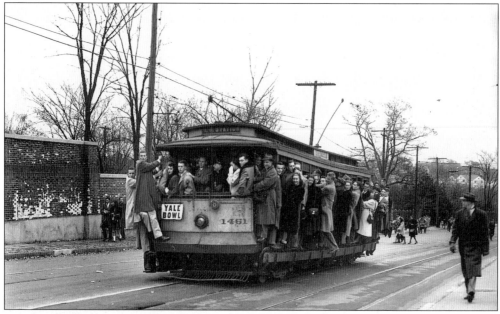

An era ends as car 1461 brings a full load of fans to Yale Bowl on November 22, 1947, the last college football game served by Connecticut Company streetcars. On Thanksgiving Day, the cars made one final trip with a much smaller crowd to the West Haven High School–Hillhouse High School football game. (Kent Cochrane photograph, George Baehr collection.)

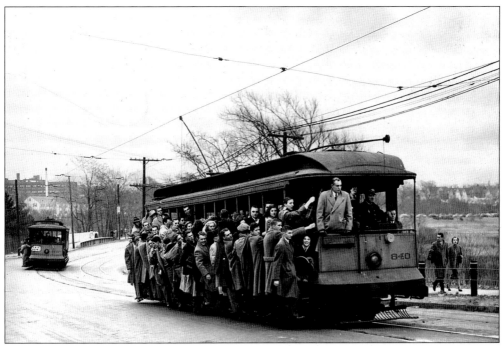

Seven Saturdays each year, packed trolley cars traveled up Chapel Street, Derby Avenue, and Derby Turnpike to Yale Bowl, from opening day on November 21, 1914, until November 22, 1947. (Branford Electric Railway Association collection.)

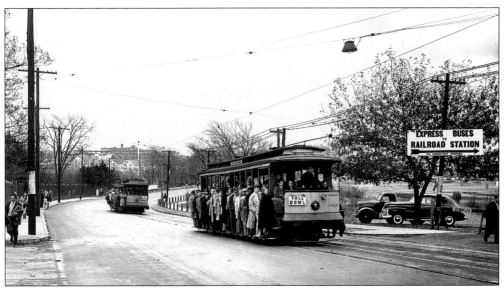

Express bus service from the railroad station to Yale Bowl was added to the local trolley service in 1936. (Charles Duncan photograph, Branford Electric Railway Association collection.)

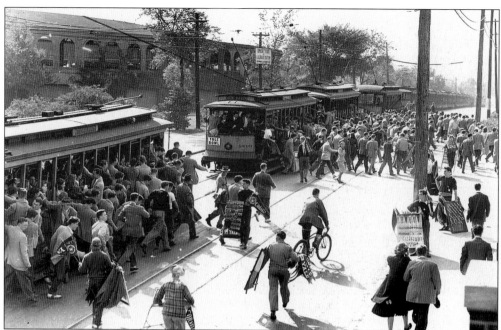

A typical football crowd arrives at Yale Bowl, with Yale Field visible in the background. (Clifford Scofield photograph, Branford Electric Railway Association collection.)

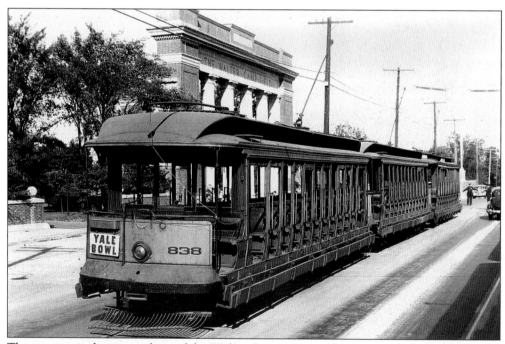

Three open cars layover in front of the Walter Camp Memorial Gateway of 1928 at Yale Bowl. Walter Camp played for Yale from 1877 to 1882 and was Yale's first football coach. Camp established football's fundamental rules, such as 11 players per side, the scrimmage line, center snap, and four downs per sequence. (Jack Beers photograph, George Baehr collection.)

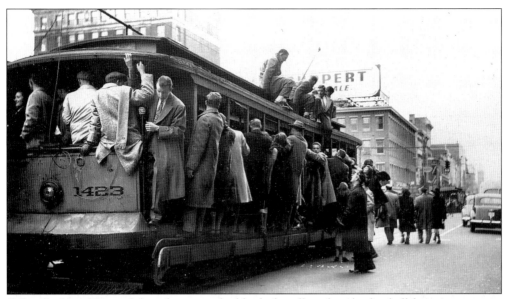

Officially, New Haven did not have any double-deck trolleys, but the football fans went upstairs anyway. The car will soon head west (to the left) so the running boards on the devil-strip side (the side between the tracks) are up—not that the football fans cared one bit. Starter Henry Connolly, on the street next to the car, will not let the crew depart until all passengers are (relatively) safely aboard. (John H. Koella photograph.)

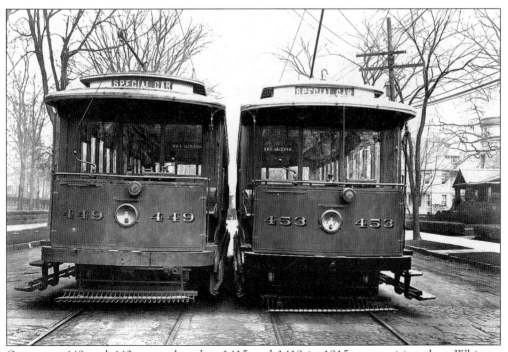

Open cars 449 and 443, renumbered as 1415 and 1419 in 1915, are positioned on Whitney Avenue on November 22, 1912, to show the clearance between cars. (Fred Stone photograph, Branford Electric Railway Association collection.)

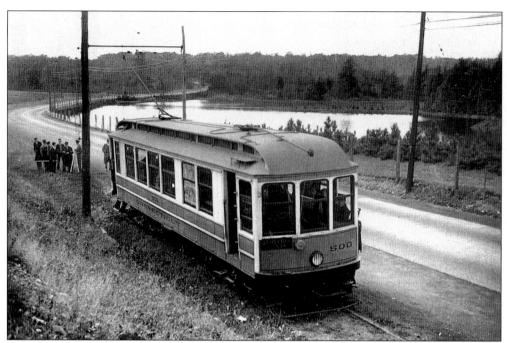

Car 500 is at the Plainfield Avenue, West Haven, fare limit on the line to Derby, on October 27, 1940. Across Derby Turnpike is one of the Maltby Lakes, which were reservoirs created for the Fair Haven Water Company in the 1860s. (Charles Duncan photograph, George Baehr collection.)

Two cars meet on Derby Turnpike at Yale Field on Friday, April 9, 1918. With thousands of football fans and packed open cars seven Saturdays a year, it is easy to forget that the rest of the time, the suburban trolley line between New Haven, Derby, and points north was a commuter route just like all the other lines. (Branford Electric Railway Association collection.)

In this winter scene, only the streetcar tracks have been cleared on February 27, 1934, as eastbound car 774 approaches Howe Street on the narrow portion of Edgewood Avenue originally known as Martin Street. (Branford Electric Railway Association collection.)

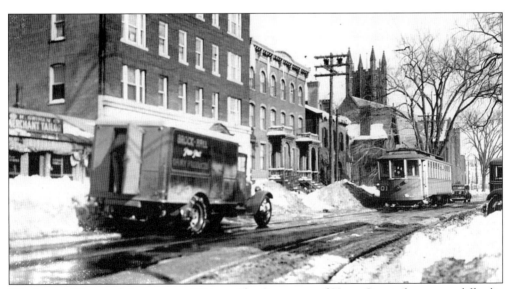

Westbound Edgewood Avenue car 1604, on Elm Street east of Howe Street, faces some difficulty getting past a delivery truck on March 1, 1934. (Branford Electric Railway Association collection.)

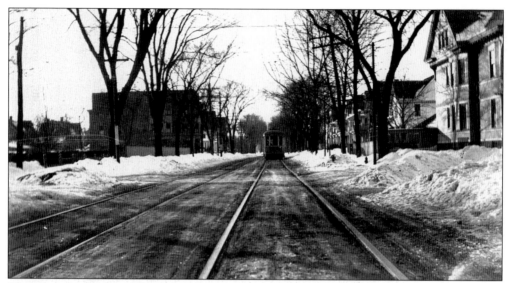

This photograph shows Edgewood Avenue west of Sherman Avenue on February 18, 1923. (Charles Rufus Harte–Connecticut Company photograph, Branford Electric Railway Association collection.)

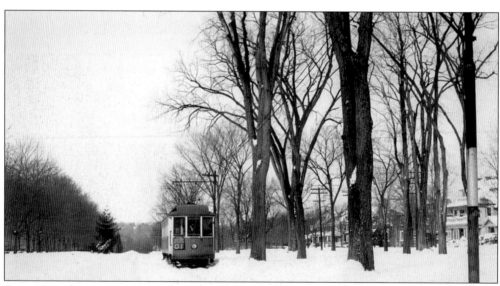

Car 1150 is shown traveling eastbound on Edgewood Avenue at Brownell Street on January 24, 1935. Behind the car, the wide median ends and the street narrows to cross the bridge over the West River. Edgewood Park, laid out by architect Donald Grant Mitchell c. 1889, is at the left. Mitchell's estate, Edgewood, west of Alden Avenue, was subdivided after World War I into one of New Haven's finer residential areas. (Charles Rufus Harte–Connecticut Company photograph, Branford Electric Railway Association collection.)

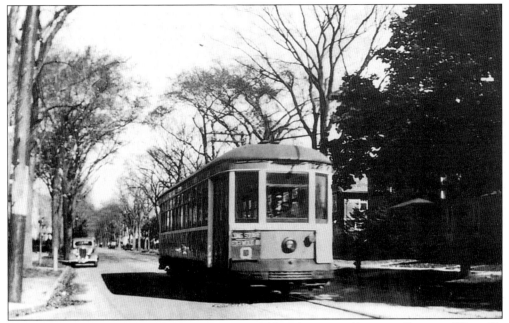

Edgewood Avenue streetcars began running up Alden Avenue to Fountain Street in Westville in 1900 and remained in service until October 1936. Car 1727 is shown in the fall of 1935. (John Somers photograph, George Baehr collection.)

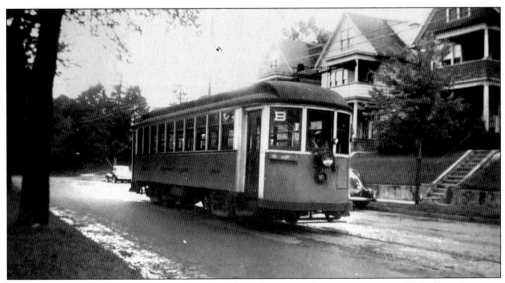

This eastbound chartered car, having just left the Davis Street turnout on Whalley Avenue, starts down the steep grade toward the center of Westville. (Branford Electric Railway Association collection.)

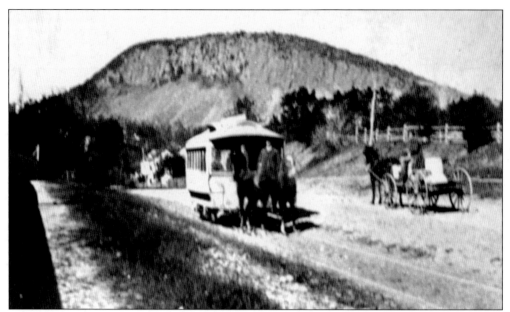

A Fair Haven and Westville Railroad horsecar heads down Whalley Avenue back to New Haven from the manufacturing village of Westville nestled below West Rock. The water of the West River flowing through the village powered several paper mills and other factories in the 18th and 19th centuries. (Library of Congress collection.)

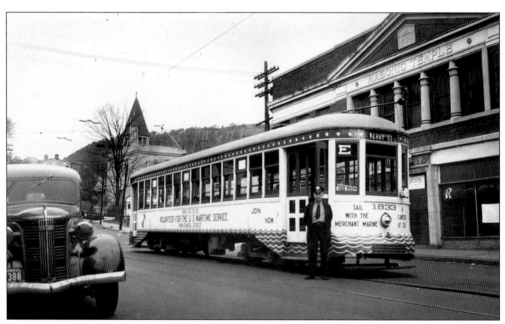

Car 1833 is shown with a World War II advertising paint scheme during a layover on Whalley Avenue at Blake Street in the Westville section of New Haven on October 20, 1943. (Harry Hall photograph, Branford Electric Railway Association collection.)

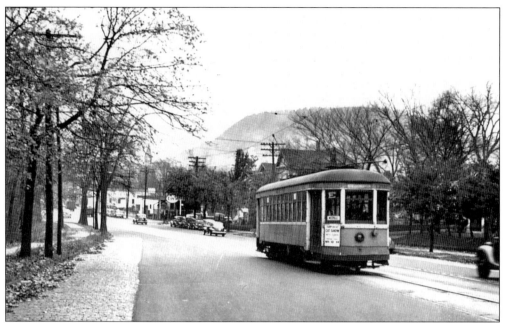

Car 1789, on Whalley Avenue, is shown passing the northern tip of Edgewood Park on Armistice Day, November 11, 1947. The main road to Westville originally ran along Blake and Goffe Streets. The Litchfield Turnpike, renamed Whalley Avenue within the New Haven city limits, was laid out in 1797 along a little-used colonial path, and the wide thoroughfare soon supplanted the old road. (John Stern photograph, Branford Electric Railway Association collection.)

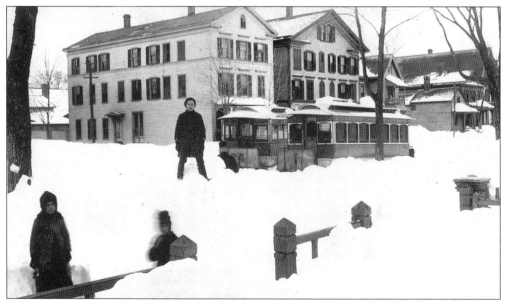

Two Fair Haven and Westville Railroad cars are abandoned on Whalley Avenue at Sperry Street after the blizzard of 1888. The year before, snowdrifts kept the horsecars off the street for nearly two months. (New Haven Colony Historical Society collection.)

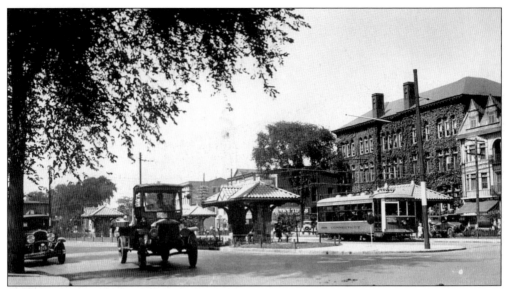

Car 2282 at the Broadway trolley station ready to head east on Elm Street on August 26, 1929. (Charles Rufus Harte–Connecticut Company photograph, Branford Electric Railway Association collection.)

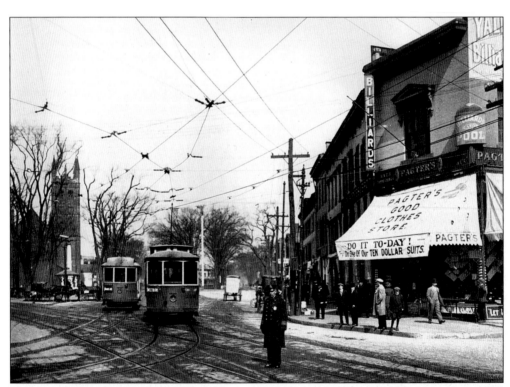

This view of Broadway faces west from Elm and York Streets c. 1910. Car 152 (renumbered 670 in 1915), on the right, is a 1902 Brill product. The car on the left is one of the Wason cars built between 1905 and 1907. (New Haven Colony Historical Society collection.)

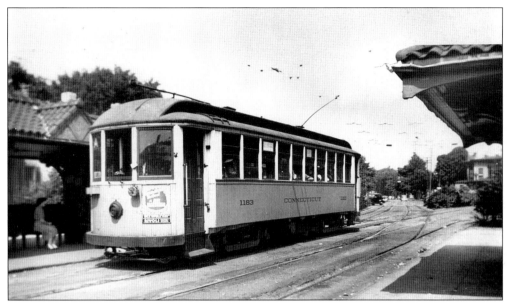

Car 1163, on a Shelton Avenue–Canner Street run, stops at the Broadway trolley station on July 25, 1943. Whalley Avenue tracks are directly behind the car. (Jack Beers photograph, George Baehr collection.)

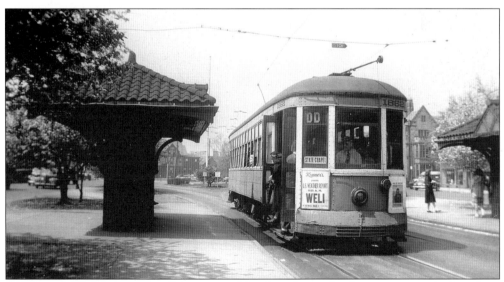

Car 1862, inbound from Dixwell Avenue and Pershing Street, loads passengers at the Broadway trolley station on May 12, 1948. (Roger Somers photograph. George Baehr collection.)

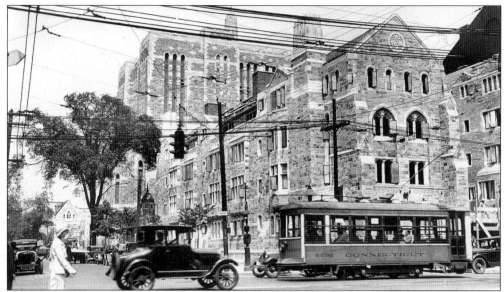

Safety car 2292 passes by Yale University's new Trumbull College at Elm and York Streets on May 22, 1930. (Charles Rufus Harte–Connecticut Company photograph, Branford Electric Railway Association collection.)

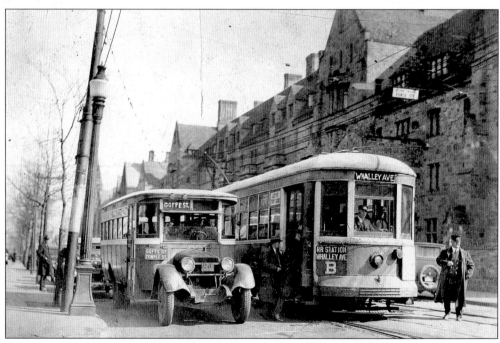

A White model 50 or 50-A bus built *c.* 1924 waits for two men to board a one-man-operated car on Elm Street. The lettering on the roll signs on the vehicles was enhanced by the photographer for use in a Connecticut Company advertisement. (Charles Rufus Harte–Connecticut Company photograph, Branford Electric Railway Association collection.)

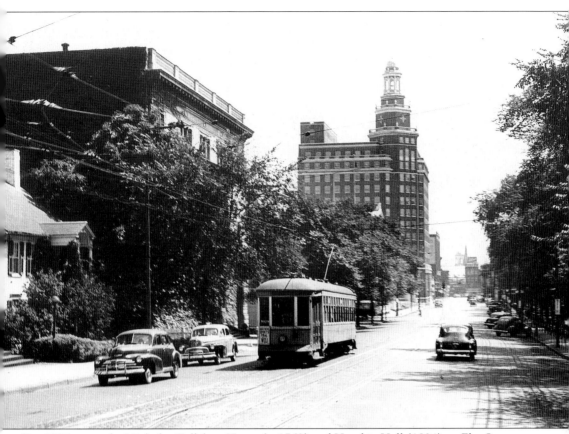

Car 1887 passes the Nicholas Callahan House (*c.* 1762) and Hendrie Hall (1894) on Elm Street between Temple and College Streets on August 29, 1948. In the late 18th century, the upper town around the green replaced the lower town on the waterfront as the city center, and Elm Street became the most fashionable residential area. The large building in the background is the Union Trust Company (1927), built when the city's commercial center was shifting northward up Church Street from Chapel Street. (Jack Beers photograph, George Baehr collection.)

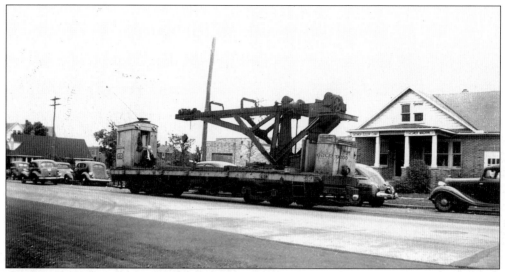

Crane 0200 is shown at the end of track on Dixwell Avenue at Benham Street in Hamden on June 18, 1942, two blocks south of the Wilbur Cross Parkway. Beyond the parkway and the car line, the frame houses and trees that usually surround Dixwell trolleys give way to open space with only a few homes. Development of the automobile-oriented suburbs to the north will not begin until after World War II, and the new buildings will look nothing like those south of the parkway. (John H. Koella photograph.)

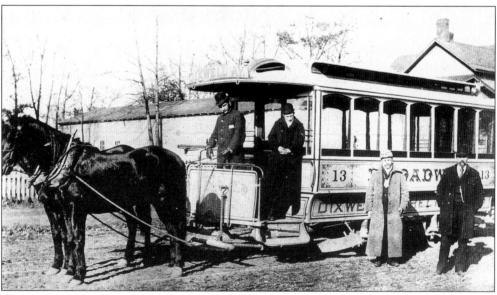

Winter always presents challenges—especially for the people on an unheated horsecar. Drivers are out in the rain, snow, and cold without much protection other than several layers of clothing under an overcoat. Conductors get inside for a minute or two between stops, but the temperature inside is no different than outside, and the straw spread on the floor to keep the passengers feet warm does little good. (Branford Electric Railway Association collection.)

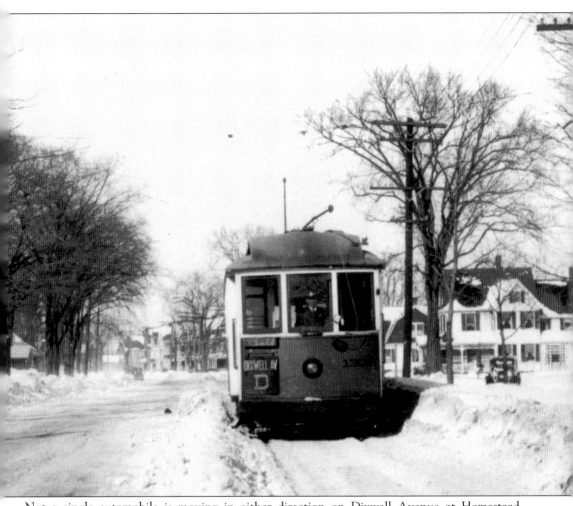

Not a single automobile is moving in either direction on Dixwell Avenue at Homestead Avenue in Hamden on Saturday, February 27, 1934, but streetcars are back on schedule. (Branford Electric Railway Association collection.)

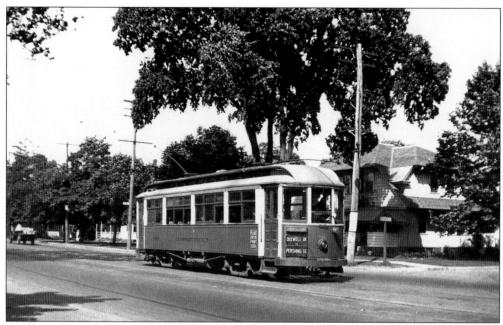

Car 773 turns back at the end of double track on Dixwell Avenue at Pershing Street in Hamden on Thursday, June 14, 1934. The car was one of 15 built for the Consolidated Railway in 1906 by the Jewett Car Company of Newark, Ohio. (William H. Watts photograph, Branford Electric Railway Association collection.)

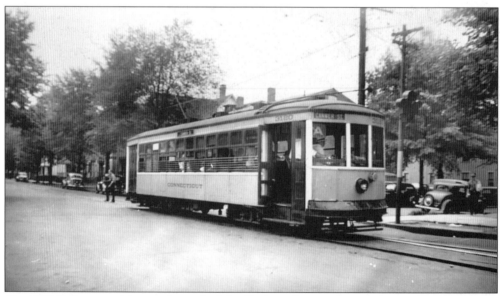

Car 3120 is shown waiting at the end of the Shelton Avenue line in August 1942. (John H. Koella photograph.)

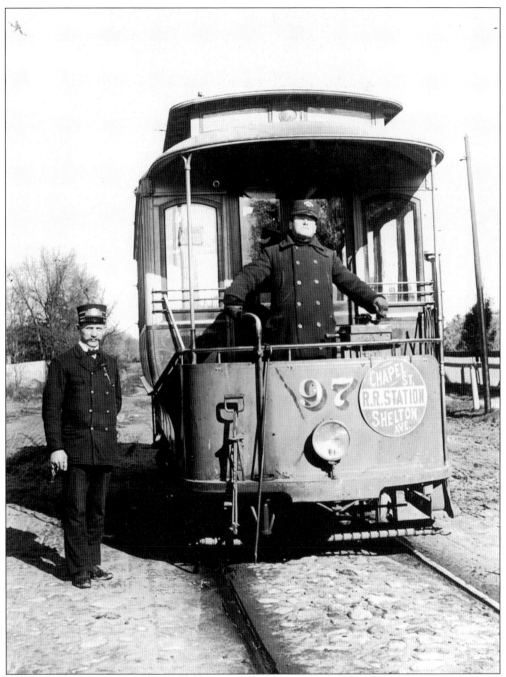

Motorman James "Curly" Condon and conductor Francis Craddock pose with car 97 at the end of the Shelton Avenue line on Sunday, November 12, 1899. Twelve cars like this were received from Jackson and Sharpe of Wilmington, Delaware, in 1894 to inaugurate the Fair Haven and Westville Railroad's trolley service. The Shelton Avenue line was built by the New Haven and Centreville Horse Railway just after the Civil War and was absorbed into the Fair Haven and Westville Railroad in 1897. (H.B. Townsend photograph, Branford Electric Railway Association collection.)

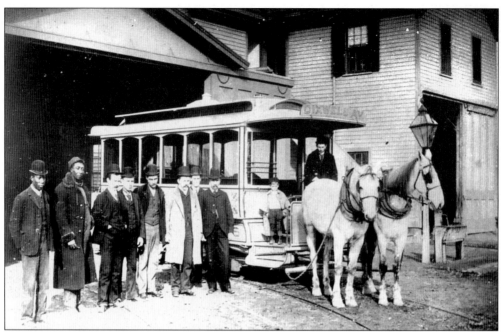

New Haven and Centreville Horse Railway car, staff, and motive power pose at the Shelton Avenue carbarn. (Branford Electric Railway Association collection.)

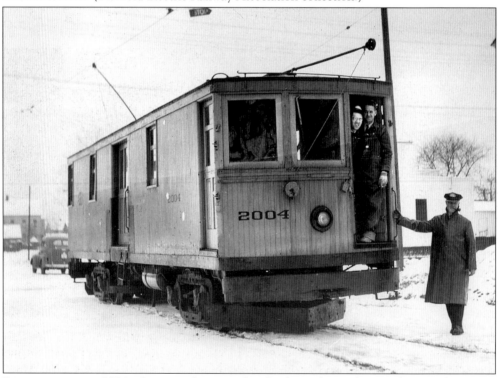

Former express car 2004 is being used to spread rock salt on the tracks to melt ice and snow. In the doorway, two men (identified as Schultz and Brennan) handle the salt. Hubert "Ham" Hamilton, standing next to the car, handles the car's operation. (John H. Koella photograph.)

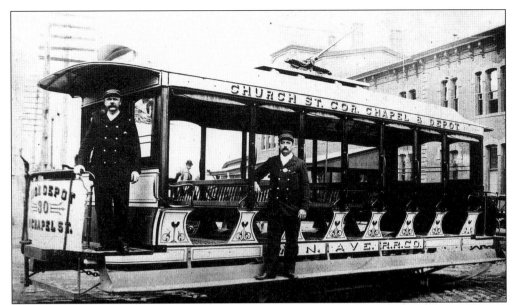

Motorman C.S. Allen and conductor O.I. Woodford are shown posing for the photographer on Winchester Avenue Railroad car 30. (Branford Electric Railway Association collection.)

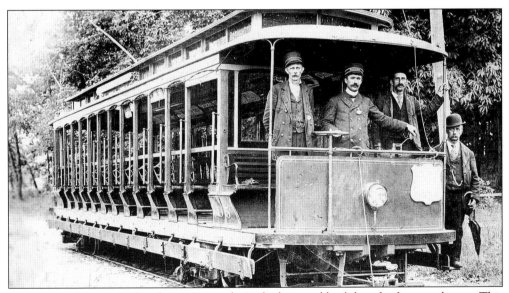

Winchester Avenue Railroad car 95 provides a platform and backdrop for four gentlemen. This company, chartered in 1889, was the last independent street railway in the city, not coming under the control of the Fair Haven and Westville Railroad until 1901. On May 20, 1904, it was merged into the Fair Haven and Westville. Three days later, the latter was taken over by the Consolidated Railway. The car was built in 1899, renumbered 311 in 1901, renumbered 510 in 1915, and scrapped in 1926. (Branford Electric Railway Association collection.)

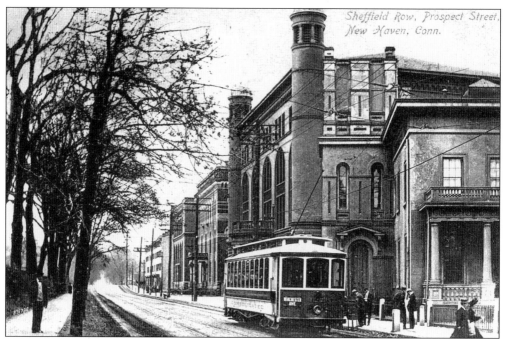

This postcard view shows Consolidated Railway car 127 heading up Prospect Street toward the Sheffield Laboratory of Engineering Mechanics. On the left is the Grove Street Cemetery of 1796, and the bump on Prospect Street in the distance is the bridge over the New Haven and Northampton Railroad. (Branford Electric Railway Association collection.)

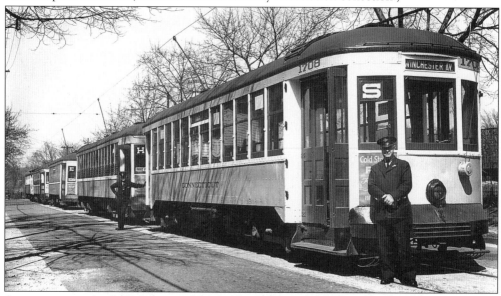

Streetcars await the shift change at the Winchester Repeating Arms Company in Newhallville. This neighborhood took its name from the Newhall Carriage Company, which was situated next to the Farmington Canal. The course of the 1828 canal was converted into the New Haven and Northampton Railroad between 1846 and 1848. Winchester moved into a new factory next to the railroad in 1870, and the manufacture of firearms replaced carriage making as New Haven's largest industry. (George Rouch photograph, George Baehr collection.)

Four
LINES NORTH AND NORTHEAST

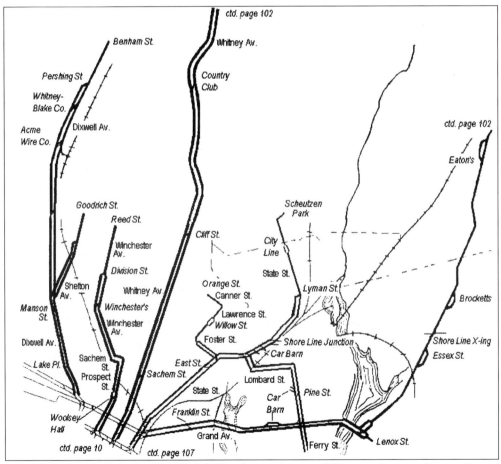

ctd. page 102

Benham St.

Whitney Av.

Pershing St

Country
Club

Whitney-
Blake Co.

Acme
Wire Co.

Dixwell Av.

ctd. page 102

Eaton's

Goodrich St.

Reed St.

Scheutzen
Park

Winchester
Av.

Cliff St.

City
Line

Division St.

State St.

Shelton
Av.

Whitney Av.

Orange St.

Lyman St.

Brocketts

Canner St.

Manson
St.

Winchester's

Lawrence St.

Winchester
Av.

Willow St.

Shore Line X-ing

Dixwell Av.

Foster St.

Shore Line Junction

Essex St.

Sachem
St.

East St.

Car Barn

Lake Pl.

Prospect
St.

Sachem St.

Lombard St.

Pine St.

State St.

Car
Barn

Woolsey
Hall

Franklin St.

ctd. page 10

Grand Av.

ctd. page 107

Ferry St.

Lenox St.

The north and northeast lines included Winchester Avenue, Whitney Avenue, Canner Street, State Street, Ferry and Pine Streets, the Shore Line Electric Railway, and Grand Avenue.

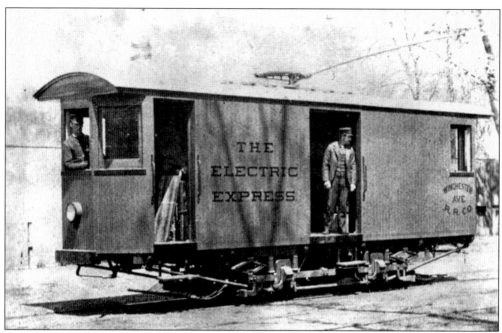

The trolley express business in Connecticut was started by Charles M. Cole of Bridgeport. In 1899, Cole's Electric Express entered into an agreement with the Winchester Avenue Railroad, giving Cole the exclusive right to transport merchandise over the railway. Cars, power, crew, and a terminal in New Haven were provided by the railway. Car 20 was a work car built by the railway in 1894 and was converted into an express car. (Branford Electric Railway Association collection.)

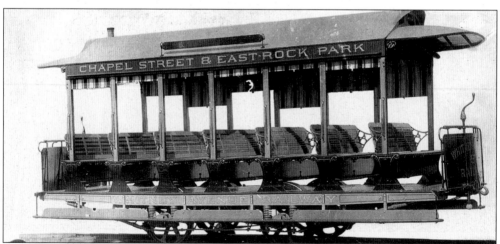

Whitney Avenue Horse Railroad open horsecar 9 sits on the transfer table at the J.G. Brill factory in Philadelphia c. 1871. The company was chartered in 1871, leased to the State Street Horse Railroad in 1887, conveyed to the New Haven Street Railway in 1893, absorbed by the Fair Haven and Westville Railroad in 1898, and taken over by the Consolidated Railway in 1904. (Branford Electric Railway Association collection.)

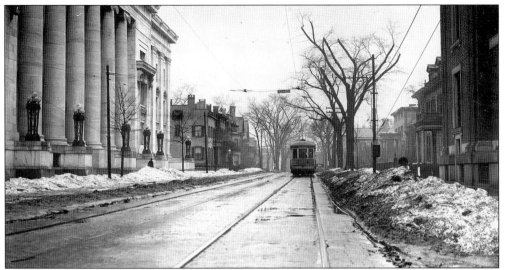

Church Street is deserted on Sunday, January 21, 1923, as a solitary northbound streetcar passes the New Haven County Court House on the corner of Elm Street. (Charles Rufus Harte photograph, Branford Electric Railway Association collection.)

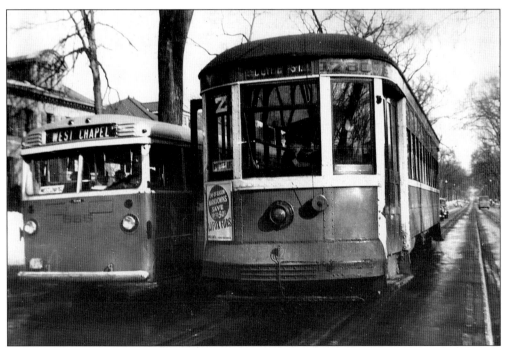

Whitney Avenue streetcars were replaced by buses on January 1, 1937. On January 13, 1943, trolleys began running once again on Whitney Avenue south of Cliff Street near the New Haven city line. Cars provided local service on weekdays, and buses to and from Spring Glen in Hamden ran express. On Sundays and evenings, local buses covered the entire route. Trolley service on Whitney Avenue ended on November 15, 1947. (Jack Beers photograph, George Baehr collection.)

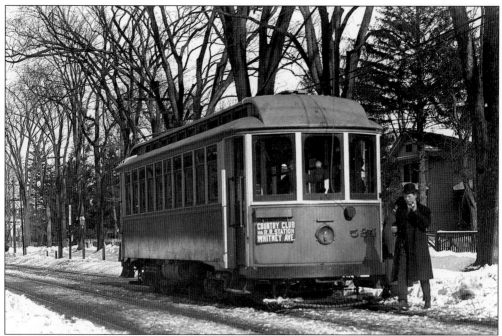

Car 520 stops at Whitney Avenue and Putnam Street in 1910. Whitney is part of an old colonial road incorporated into the Hartford Turnpike in 1898. When the Mill River was dammed in 1860 (creating Lake Whitney and New Haven's first water supply), the avenue was relocated west of the lake and river. The New Haven Country Club, founded in 1898, was built on the Davis farm on Hartford Turnpike and was reached via a suspension footbridge over Lake Whitney. (New Haven Colony Historical Society collection.)

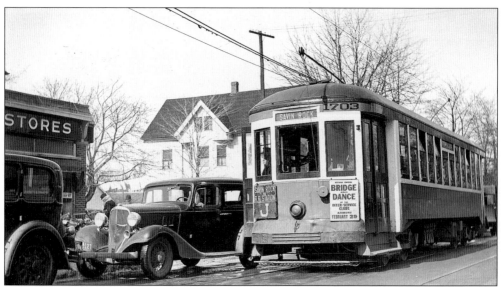

Car 1703 has trouble clearing parked automobiles on Whitney Avenue at Putnam Street in the Whitneyville section of Hamden. Whitneyville grew up in the early 19th century around the firearms factory of inventor Eli Whitney at Armory Street, a half-mile to the south. (Branford Electric Railway Association collection.)

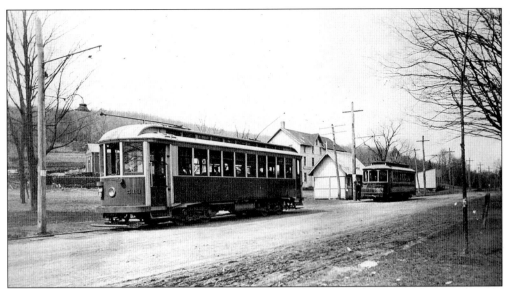

This photograph shows two cars stopped at Mount Carmel in the northern part of Hamden. At this point, the car is on the tracks of the Connecticut Railway and Lighting Company, which was leased and operated by the Consolidated Railway and the successor Connecticut Company, from 1906 until 1936. (Branford Electric Railway Association collection.)

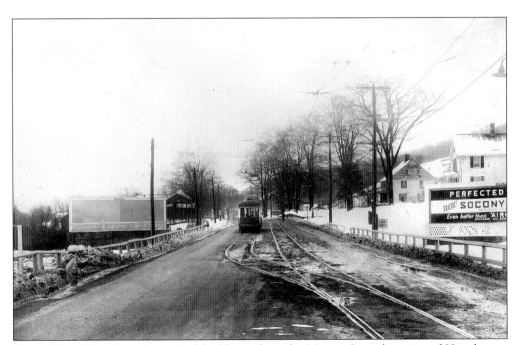

A northbound car is at the end of double track in the Mount Carmel section of Hamden on February 13, 1931, a half-mile north of the boundary between the New Haven and Waterbury Divisions of the Connecticut Company. (Branford Electric Railway Association collection.)

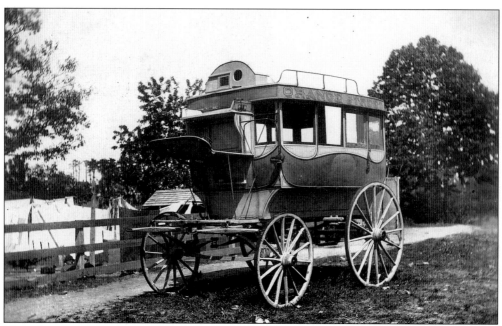

This photograph shows a 19th-century Orange Street omnibus. Orange Street was originally called Mill Lane, as it led to the New Haven Colony's first gristmill, located (naturally) on the Mill River. (Library of Congress collection.)

An Orange Street bus is shown during a layover at the end of the line on Saturday, April 30, 1932. Motor buses were introduced to the city in February 1900, when the first of three vehicles began operating on Orange Street. One of New Haven's first parks, built in 1880, sits atop East Rock above the bus. (Charles Rufus Harte photograph, Branford Electric Railway Association collection.)

Car 3116 is shown here *c.* 1941 at Canner and Orange Streets. This was the last new trolley line built in New Haven, first appearing on official maps in 1912. (Robert Williams photograph, Branford Electric Railway Association collection.)

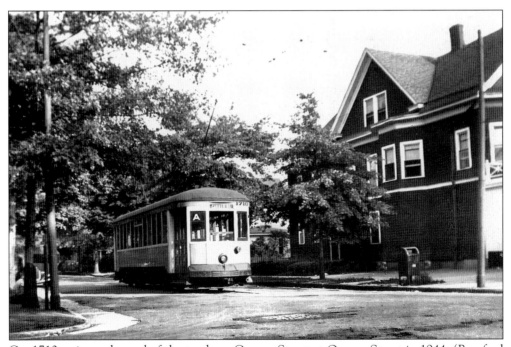

Car 1710 waits at the end of the track on Canner Street at Orange Street in 1944. (Branford Electric Railway Association collection.)

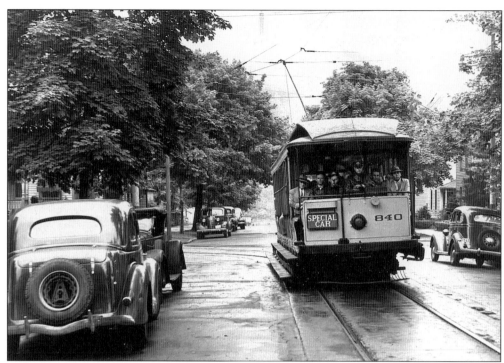

Excursion car 840 turns from Canner Street onto Foster Street on the last day of operation. (Jack Beers photograph, George Baehr collection.)

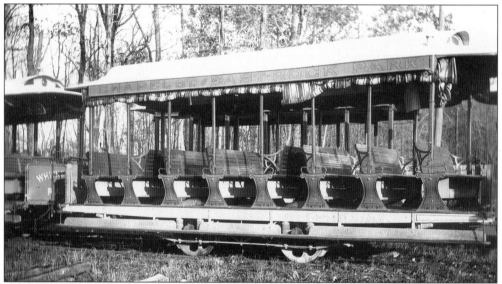

The main streets of colonial New Haven were two creeks that flowed into the harbor at Water Street. Neck Lane followed East Creek northward to the Neck Bridge over the Mill River. At the end of the 18th century, Neck Lane was incorporated into the Middletown Turnpike. When the tolls were eliminated, the road became State Street, one of the city's principal commercial thoroughfares. In 1868, the State Street Horse Railroad was chartered and served the area with cars like the one shown just after replacement by electric cars in 1892. (Library of Congress collection.)

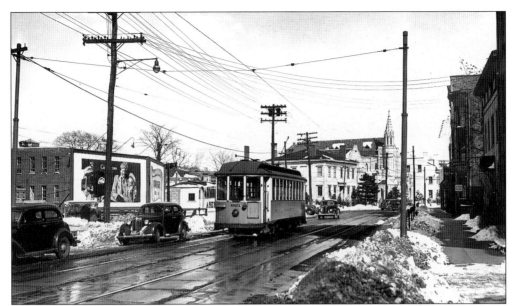

Car 861 is shown on State Street between Wall and Grove Streets on the edge of downtown New Haven in February 1947. State Street's old name of Neck Lane was sometimes corrupted in the early 19th century to Negro Lane, referring to the neighborhood around Grove Street between State and Olive Streets on the outskirts of town. Many of the houses in the area were owned by middle-class black families. (Branford Electric Railway Association collection.)

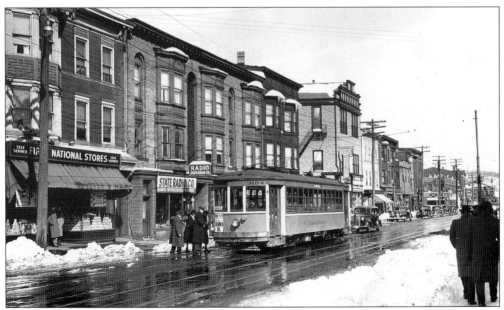

Car 3124 is shown on State Street between Bishop and Edwards Streets in February 1947. (Branford Electric Railway Association collection.)

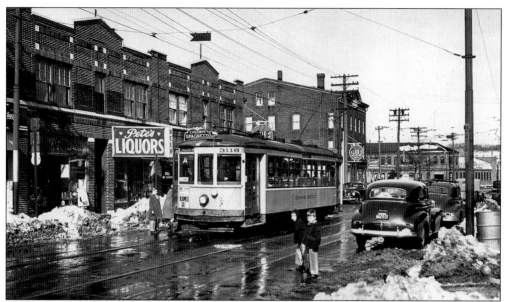

Car 3118 is shown at State and Edwards Streets in February 1947. (Branford Electric Railway Association collection.)

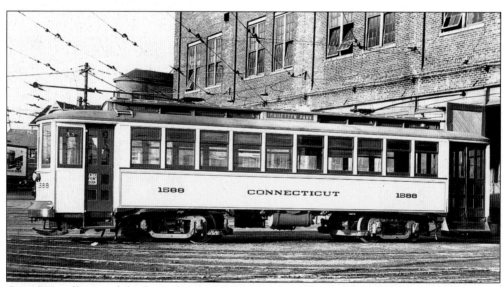

Car 1588 pulls out of the lower level of the James Street barn. The "Schuetzen Park" on the roll sign refers to a popular beer garden, picnic ground, and shooting gallery at the end of the State Street line. The park catered to New Haven's German-American community. (Branford Electric Railway Association collection.)

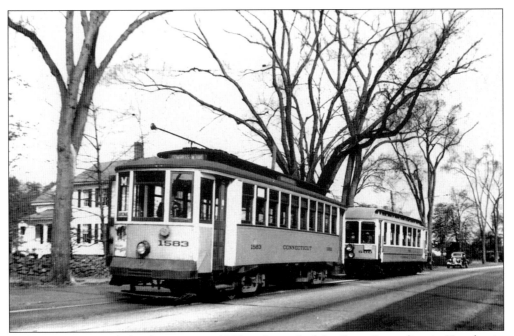

Parlor car 500 waits behind service car 1583 at the end of the State Street line in Hamden in the winter of 1947. (George Baehr collection.)

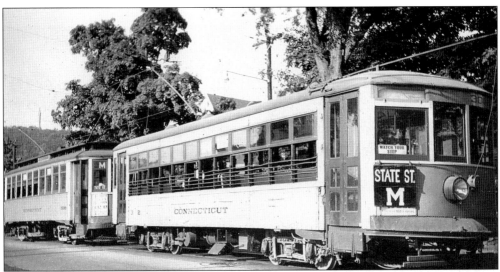

Two cars wait at the end of the line at State and Merritt Streets. The car closer to the camera is probably in tripper service. If a car was late reaching the end of the line, the tripper would leave at the scheduled time. When the cars met, the crew changed cars; the regular operator continued along the route, and the tripper took the late car back to the end of the line to begin the cycle over again. State Street (Route 5), with its heavy truck traffic and frequent delays, made trippers a necessity. (E.W. Heinmann photograph, Branford Electric Railway Association collection.)

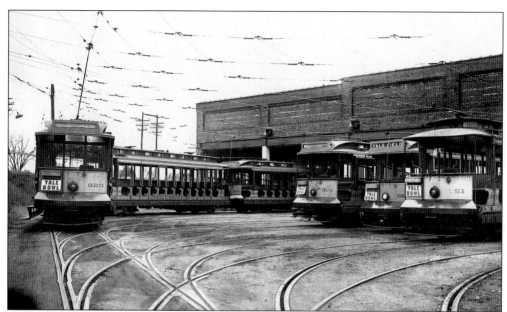

The upper level of the Connecticut Company's barn at State and James Streets holds an assortment of open cars waiting to carry the crowds to the football game on Saturday, November 23, 1940. During football season, some 60,000 fans traveled from downtown New Haven to Yale Field for each game, and only the fleet of opens could handle crowds of that size. Had it not been for the football crowds, Connecticut's open cars would have been retired and scrapped decades earlier. (Al Gilcher photograph, George Baehr collection.)

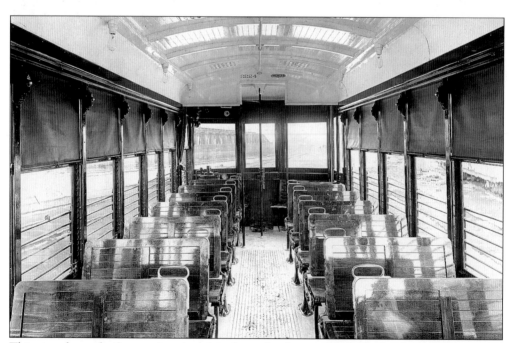

This view shows the Spartan interior of single truck safety car 2224. The hard wooden seats were never very popular with the passengers. (Branford Electric Railway Association collection.)

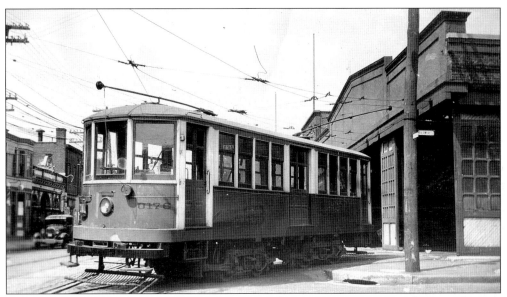

Car 0176 was built in the Connecticut Company's shop in 1907 as car 31 and was used to test the tracks for broken or poor bonds, which could lead to electrolysis. This photograph was taken in front of the Grand Avenue barn in 1934. (Branford Electric Railway Association collection.)

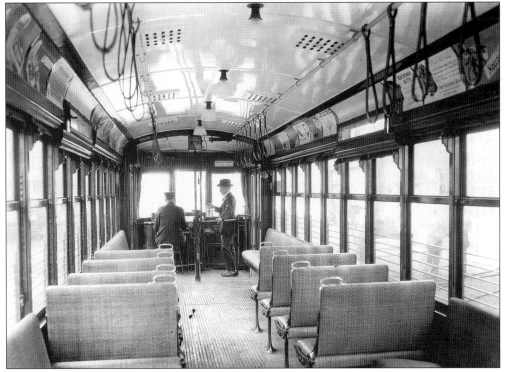

The interior of car 3120 is shown here on January 31, 1924. The most commonly used seat covering in city streetcars was rattan. (McGraw-Hill Photo Service Department photograph, Branford Electric Railway Association collection.)

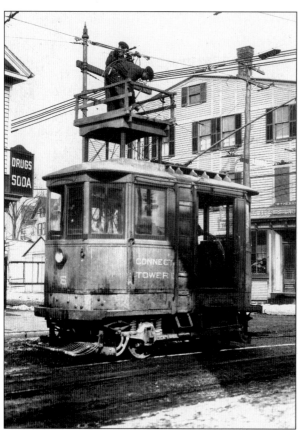

Summer heat caused the overhead wires to expand and sag, while winter cold caused the wires to contract and rise. Adjustments had to be made regularly to prevent the wires from coming off the poles. The crew on tower car 6 is shown performing the necessary maintenance work on March 3, 1916. Officially, the car was No. 066 by this date, but it took a while to change the number on nearly 2,000 vehicles after the system-wide renumbering of 1915. (Branford Electric Railway Association collection.)

Cars that were no longer needed for passenger service were often converted into service vehicles. Car 0361 entered service in Meriden in 1905 as Consolidated Railway car 102 and became Connecticut Company 812 in 1915. In 1929, it was changed into a rail grinder, which was used to remove irregularities in the surface of the tracks to provide a smoother ride. The abrasive friction block is mounted on the truck frame between the wheels, and the car was transferred to New Haven after the Meriden trolley lines were replaced between 1929 and 1931. (Branford Electric Railway Association collection.)

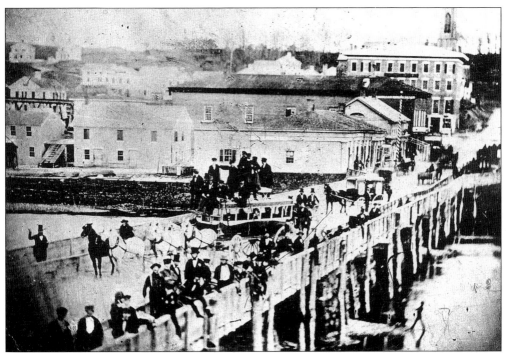

Everyone smiles and looks at the camera, including the passengers on King's Fair Haven Omnibus on the old 1791 Grand Avenue bridge. Hourly omnibus service between the railroad station near State and Chapel Streets in New Haven and King's Hotel at Grand and Front Streets in Fair Haven was provided from 8:00 a.m. to 8:30 p.m. for a 3¢ fare. (B. Warren photograph, Branford Electric Railway Association collection.)

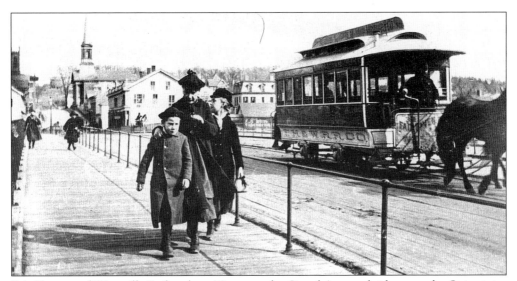

Fair Haven and Westville Railroad car 32 crosses the Grand Avenue bridge over the Quinnipiac River. The bridge and the railroad were contemporaries, both being under construction in 1860, when the city had a population of 40,000. When the line opened in May 1861, cars ran every 12 minutes to Chapel Street. (Branford Electric Railway Association collection.)

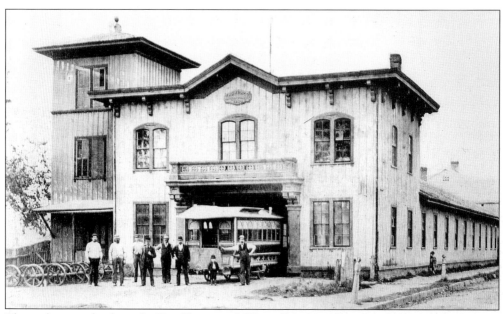

These photographs show the Fair Haven and Westville's Grand Avenue barn, at the corner of Fillmore Street. Pocket watches and facial hair are definitely in style, and hardly anyone is brave enough to go out in public without a hat. (Branford Electric Railway Association collection.)

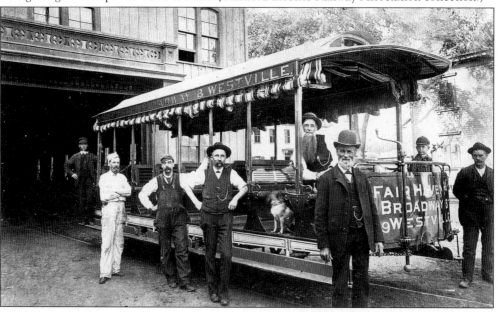

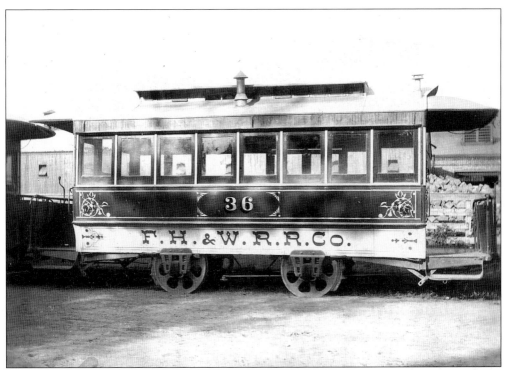

Fair Haven and Westville Railroad car 36 (shown in 1892) and car 38 (pictured in 1893) illustrate different styles of lettering and decoration. (Library of Congress collection.)

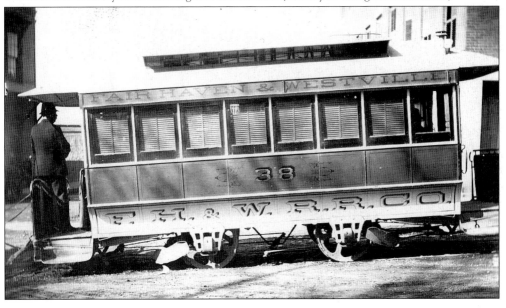

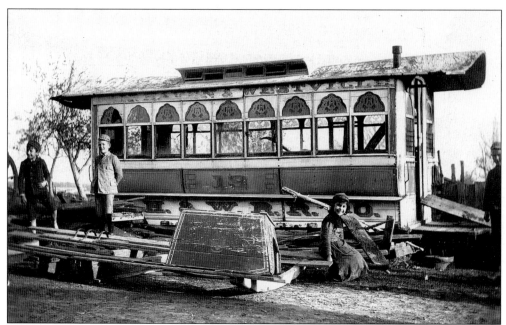

Children play around the body of one of the original ornate Fair Haven and Westville Railroad horsecars in North Haven on May 5, 1894. (Willard Van Name photograph, Library of Congress collection.)

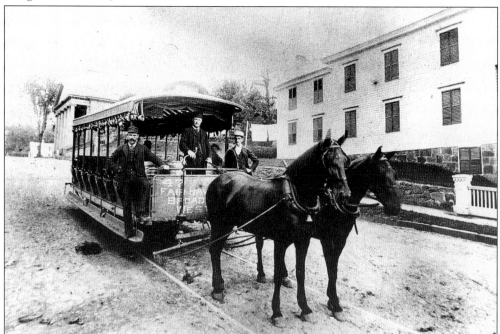

A Fair Haven and Westville Railroad car and crew wait for the photographer to take his picture at Grand and Quinnipiac Avenues. The oystering community along the Quinnipiac River at Dragon (Fair Haven) was established by the 18th century. By 1836, the 1,000 inhabitants of the area operated a fleet of 300 boats and processed 20,000 to 40,000 bushels of oysters each year. (Branford Electric Railway Association collection.)

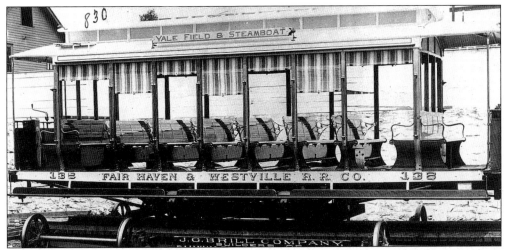

Fair Haven and Westville Railroad car 138 is sitting on the transfer table at the Brill factory in Philadelphia in 1896. The Steamboat destination sign refers to Belle Dock at the west end of the Tomlinson Bridge, where one caught a steamship for the 11-hour trip to New York City. (Branford Electric Railway Association collection.)

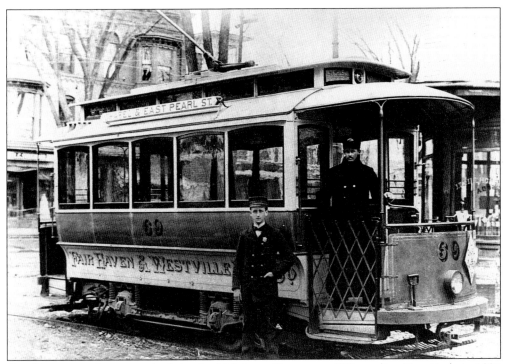

Car 69 was one of nine cars built by the J.M. Jones Company of Watervliet, New York, in 1894 and was one of the Fair Haven and Westville's first electric cars. This picture was taken two years later. In 1915, the Connecticut Company renumbered the car 174 and used it until 1921. (Branford Electric Railway Association collection.)

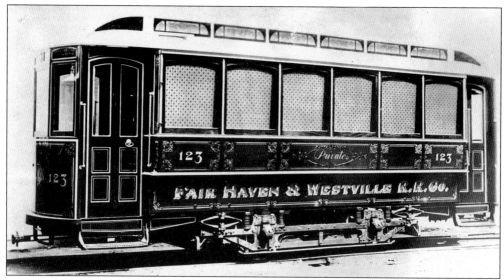

Fair Haven and Westville parlor car 123 was built by Jackson and Sharpe in 1895 and later became Connecticut Company passenger car 312. (Charles Rufus Harte–Connecticut Company photograph, Branford Electric Railway Association collection.)

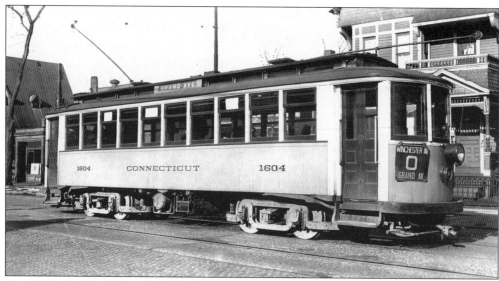

Car 1604, purchased from the Wason Manufacturing Company in 1911, was the last wooden streetcar built for the Connecticut Company. Although steel railroad and rapid-transit cars had been produced nearly a decade earlier, steel girders did not start to replace the wooden members of a streetcar's frame until about the time this car was produced. Some car parts, notably the roof, continued to be made of wood for another quarter century. (Branford Electric Railway Association collection.)

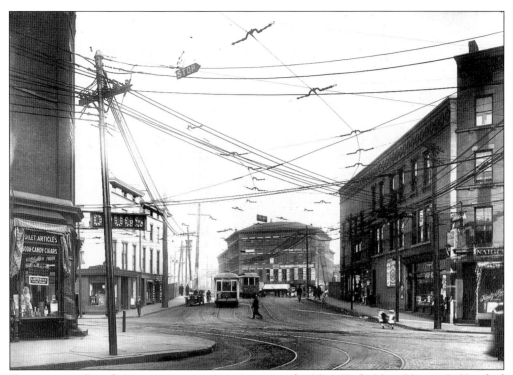

Two cars on Grand Avenue are seen crossing over the New York, New Haven & Hartford Railroad cut. The light reflecting on the rails at the intersection of Grand Avenue, Elm, and State Streets highlights the routes of the original horsecar lines. Fair Haven and Westville Railroad cars came down Grand and turned south on State, while State Street Horse Railroad cars turned onto Elm Street (in the foreground) and went west to Church Street. (Branford Electric Railway Association collection.)

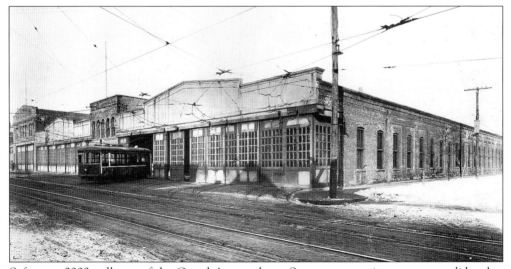

Safety car 2222 pulls out of the Grand Avenue barn. Streetcar operations were consolidated at the James Street barn during the mid-1930s, but the trolley repair shop remained at Grand Avenue until the end of rail service in 1948. (Branford Electric Railway Association collection.)

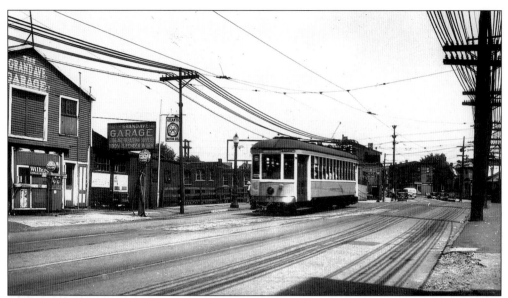

Car 1883 is shown traveling eastbound on English Island in the Mill River on July 18, 1938—the last day of streetcar service on Grand Avenue. Behind the camera is electric-power-generating Station A, and the poles on both sides of the street carry a score of feeder cables into downtown New Haven and the rest of the trolley system. (Richard Fletcher photograph, George Baehr collection.)

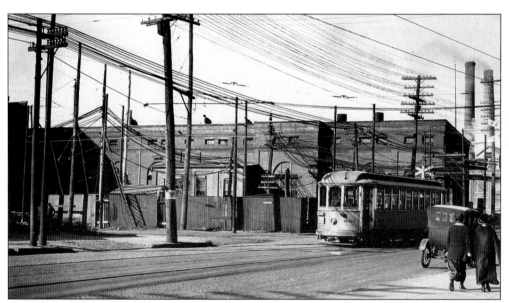

Car 861 on Grand Avenue is passing Station A on Tuesday, October 2, 1923. The original Fair Haven and Westville power-generating plant of the 1890s was on this site, and the local utility company is still situated here. (Branford Electric Railway Association collection.)

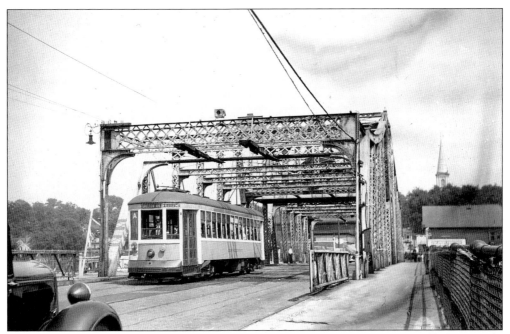

Car 1833 is shown crossing over the Grand Avenue bridge in 1938. (Harry Hall photograph, Branford Electric Railway Association collection.)

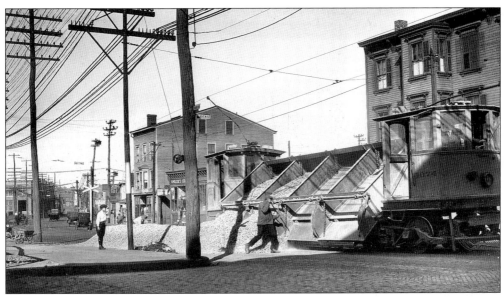

Universal dump car 1074 deposits a load of track ballast on Grand Avenue at Haven Street, two blocks east of the Mill River, on October 2, 1923. (Branford Electric Railway Association collection.)

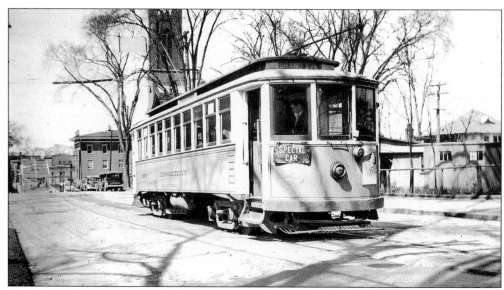

Car 1600 is shown on Grand Avenue at Lenox Street in 1938 with the St. James Episcopal Church in the background. The community east of the Quinnipiac River is Fair Haven Heights and was once part of East Haven; it was transferred to New Haven in lieu of contributing to the cost of a new bridge across the river. (Branford Electric Railway Association collection.)

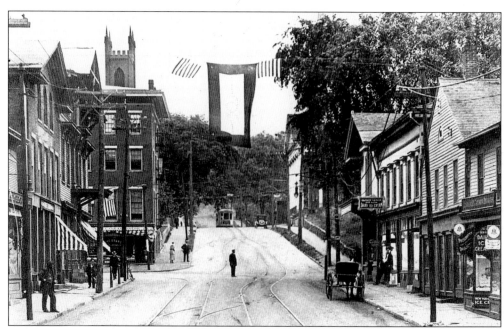

A new 1700- or 1800-series car sits at the end of the Grand Avenue line at Lenox Street c. 1917. The one-block extension up the hill was built in 1915, presumably to reduce traffic congestion at the intersection of Grand and Quinnipiac Avenues, and was the last new track laid in New Haven. (George Baehr collection.)

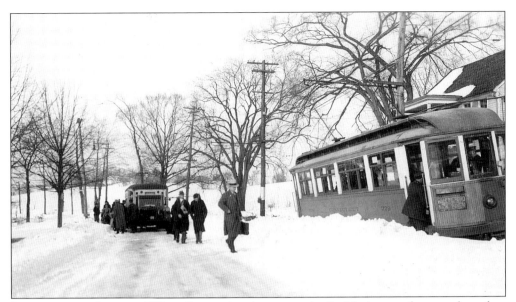

Passengers transfer to car 779 on Quinnipiac Avenue at the Smith Avenue fare zone boundary on Saturday, March 3, 1934. Normal service on this line was halfhourly as far as Montowese and hourly on the remaining seven miles of track to Wallingford. (Charles Rufus Harte–Connecticut Company photograph, Branford Electric Railway Association collection.)

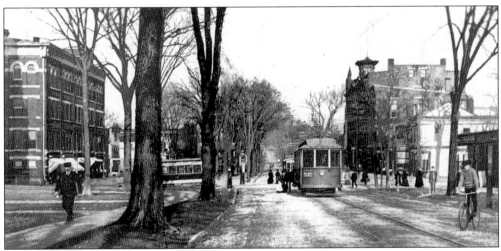

After 1931, Wallingford was the longest line entirely within the Connecticut Company's New Haven Division. The line stretched 14.4 miles from the intersection of Church and Chapel Streets and operated until March 1, 1937. This postcard view, made soon after the line opened in 1907, shows a New Haven car on Main Street, near the camera, with the local car serving North Main Street behind it. Another local car on the short Center Street line is visible behind the trees on the town green. (Branford Electric Railway Association collection.)

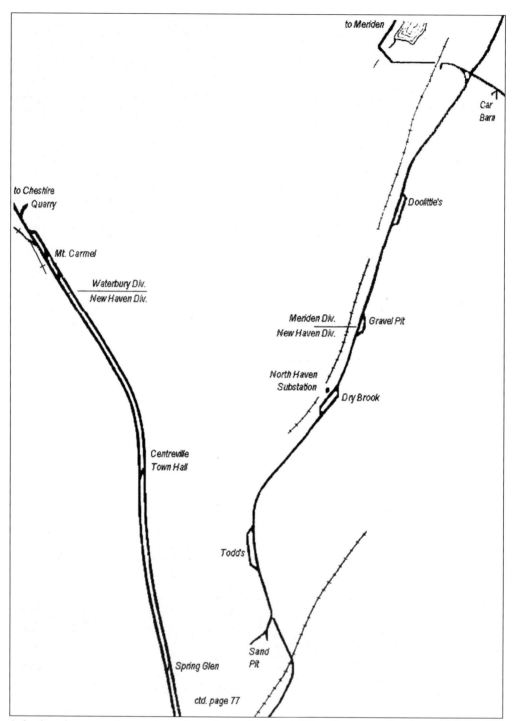

to Meriden

Car
Barn

to Cheshire
Quarry

Doolittle's

Mt. Carmel

Waterbury Div.
New Haven Div.

Meriden Div.
New Haven Div.

Gravel Pit

North Haven
Substation

Dry Brook

Centreville
Town Hall

Todd's

Sand
Pit

Spring Glen

ctd. page 77

Suburban lines to the north and northeast included Waterbury via Cheshire, Montowese, and Wallingford.

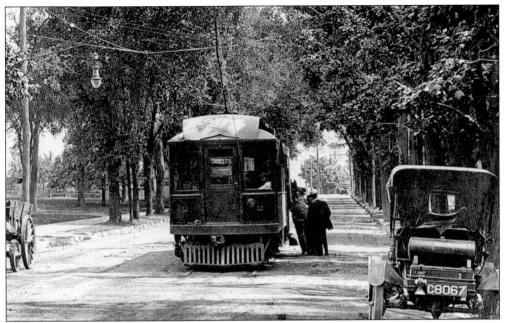

Shore Line Electric Railway car 2 is shown on Middletown Avenue shortly after operations began in 1911. The interurban started at the New Haven railroad station and used Connecticut Company tracks through downtown and up State Street. Near Ferry Street, Shore Line cars switched onto their own tracks and ran eastward through the towns along the Connecticut shore. (Branford Electric Railway Association collection.)

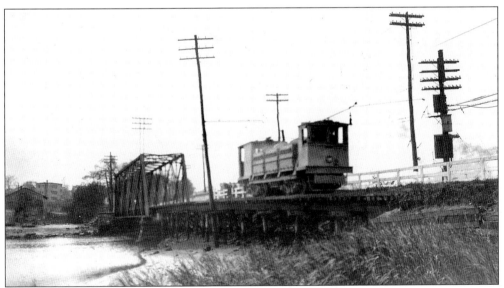

A Connecticut Company dump car is crossing the New Haven and Shore Line trestle over the Quinnipiac River on October 15, 1923, as it returns with a full load of stone from the quarry in North Branford. The New Haven and Shore Line took over the Shore Line Electric Railway's abandoned line from New Haven to Old Saybrook and operated it from 1923 to 1929. (Charles Rufus Harte–Connecticut Company photograph, Branford Electric Railway Association collection.)

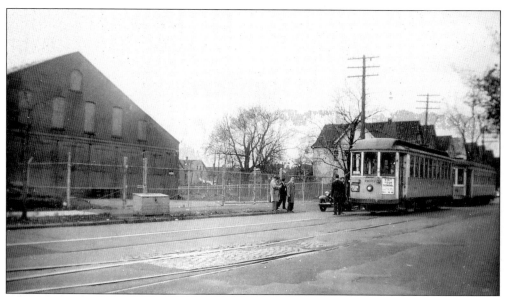

Car 865 is shown on Ferry Street at Pine Street in front of the Ferry Street carbarn on November 10, 1946. (Jack Beers photograph, George Baehr collection.)

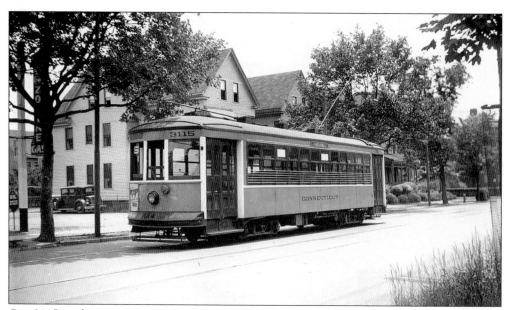

Car 3115 is shown waiting at Ferry and Pine Streets on July 3, 1940, before returning to downtown and Winchester Avenue. The Ferry Street carbarn, built by the New Haven Street Railway, is out of site behind the camera. (Branford Electric Railway Association collection.)

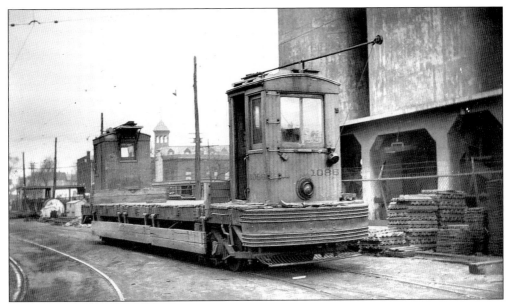

This 1935 photograph shows flat motor 1086 waiting next to Station B, the electric-power-generating plant built by the New Haven Street Railway. (Jack Beers photograph, Branford Electric Railway Association collection.)

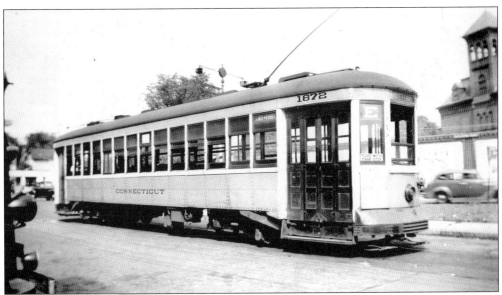

Car 1878 changes ends at Ferry and River Streets on the spur track connecting to the Manufacturer's Railroad. At the right, below the Yale Brewery, traffic moves onto the Ferry Street Bridge. Streetcars ran over the bridge until June 22, 1940, and construction of a new bridge without trolley tracks began shortly thereafter. (Jack Beers photograph, Branford Electric Railway Association collection.)

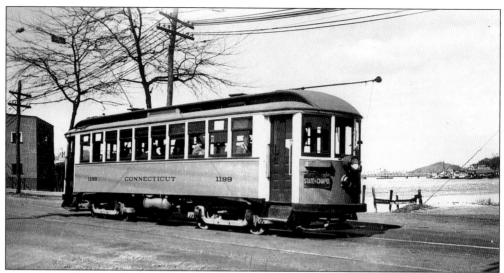

Car 1199 is shown at the foot of the Ferry Street Bridge at Farren Avenue on Wednesday, April 3, 1935. The Dragon Bridge of 1896 over the Quinnipiac River at Grand Avenue is shown in the background. Originally used on the Stamford–Norwalk line, car 1199 was frequently chartered for rail excursions around New Haven and is now preserved at the Shore Line Trolley Museum. (Branford Electric Railway Association collection.)

A northbound car from Lighthouse Park is ready to turn from the Woodward Avenue private right-of-way onto Farren Avenue on May 22, 1940. (Harry Hall photograph, Branford Electric Railway Association collection.)

Five
LINES EAST

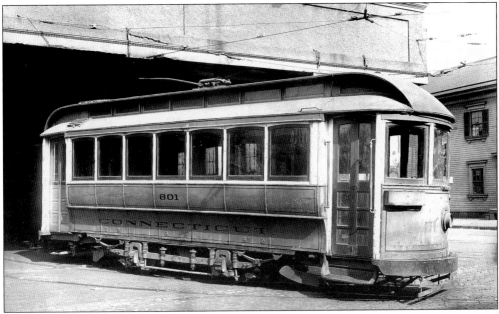

Car 801 was one of 20 cars built by the Cincinnati Car Company in 1905 for the Connecticut Railway and Lighting Company and was used in Bridgeport. The car was brought to New Haven and rebuilt for one-man service with safety controls and air brakes c. 1920. It ran on Water Street until that line from the viaduct to Steamboat was abandoned on October 3, 1924. The car was scrapped in 1926. A similar car provided service over the Tomlinson Bridge and Forbes Avenue from east of the railroad crossing to Grannis Corner. (George H. Leopold photograph, Branford Electric Railway Association collection.)

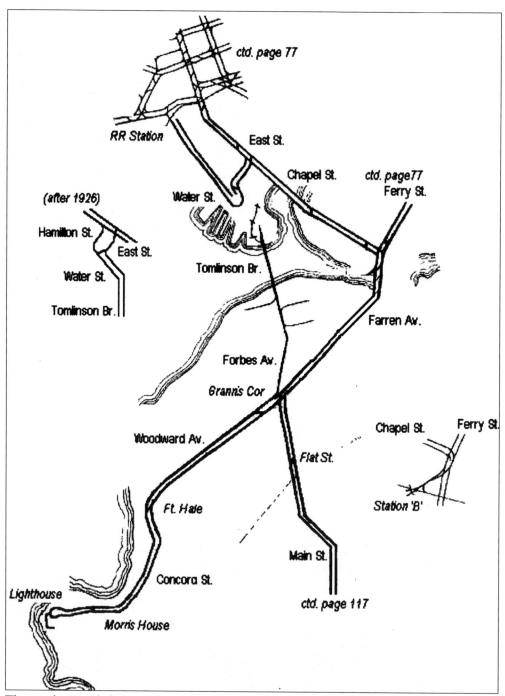

The east lines included Lighthouse, East Haven, Momauguin, and Branford.

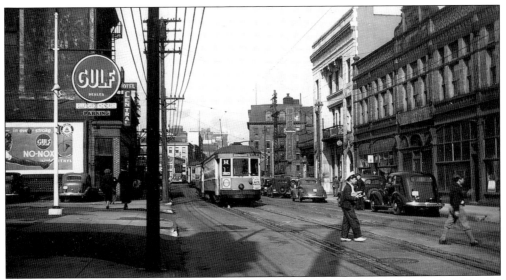

Car 1914 is on Chapel Street east of Olive Street. (Harry Hall photograph, Branford Electric Railway Association collection.)

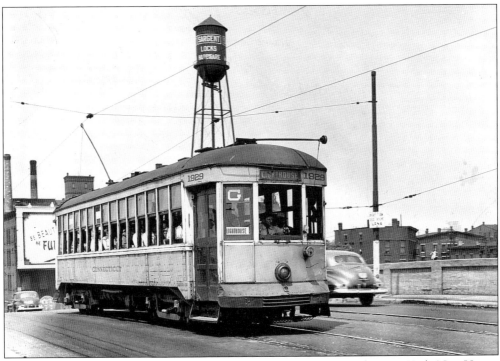

Car 1929 is shown heading eastbound on Water Street, crossing over the New York, New Haven & Hartford Railroad branch line to Belle Dock. Behind the car at Water and Wallace Streets is the Sargent and Company hardware manufacturing plant that covered four city blocks. Sargent began operating in New Haven in 1864 and was one of the major employers of the city's large Italian immigrant population. (Branford Electric Railway Association collection.)

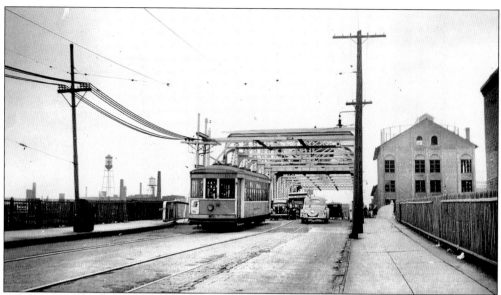

Car 3126 crosses the Chapel Street bridge over the Mill River just before trolley service on this stretch of track ended on June 22, 1940. (Harry Hall photograph, Branford Electric Railway Association collection.)

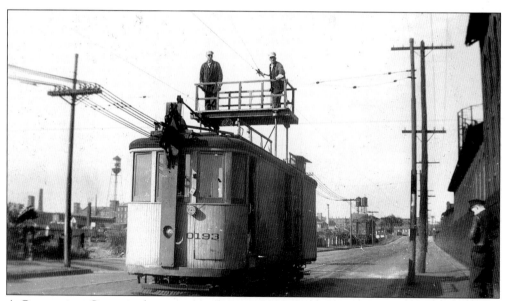

A Connecticut Company line crew on the tower of line car 0193 works on the live overhead wires on Chapel Street just east of the Mill River bridge. The date is Monday, October 12, 1942, and this line, not in service since the summer of 1940, will be put back in service in two months. (Branford Electric Railway Association collection.)

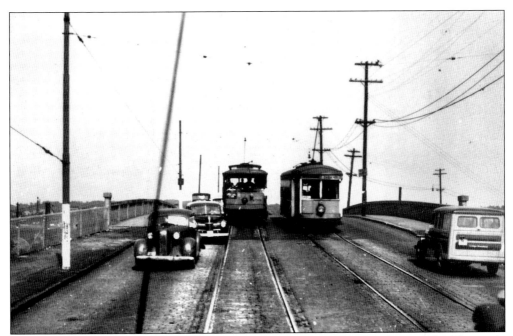

Streetcar lines built after 1895 were prohibited from crossing railroads at grade. The grade crossing at Belle Dock was eliminated in 1925, and lines from East Haven and Lighthouse were rerouted from the Ferry Street Bridge to Forbes Avenue in 1926. Cars 1439 and 3202 are shown here on the western approach to the Tomlinson Bridge on July 29, 1947. (Jack Beers photograph, George Baehr collection.)

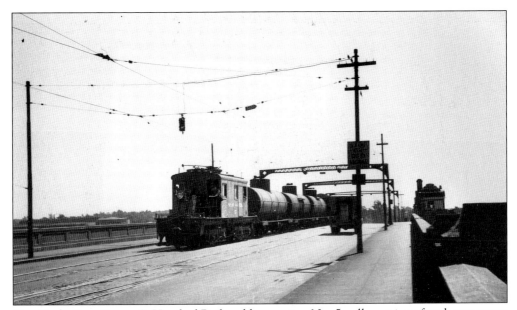

New York, New Haven & Hartford Railroad locomotive No. 5 pulls a string of tank cars across the Tomlinson Bridge in August 1941. Baldwin-Westinghouse steeple cab locomotives like this one, weighing between 50 and 60 tons, hauled freight on electric railways throughout North America. (Branford Electric Railway Association collection.)

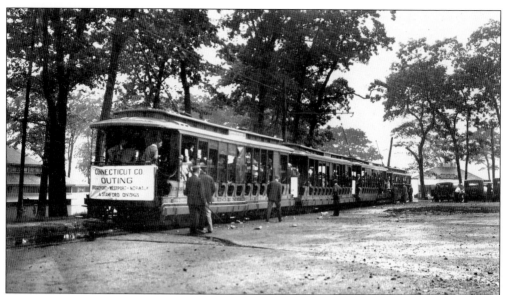

Four open cars brought Connecticut Company employees from the southwestern part of the state to a company picnic at Lighthouse Park on Thursday, July 25, 1929. Before paved highways and reliable motor vehicles, a trolley excursion was the logical way for a group to reach a common destination. (Charles Rufus Harte–Connecticut Company photograph, Branford Electric Railway Association collection.)

Car 1917 is on a piece of urban right-of-way as it enters Lighthouse Park on July 4, 1942, in a section of New Haven known as the Annex. Once part of East Haven, the 1870s summer community at Morris Cove and the area around the country crossroads called Grannis Corner were ceded to New Haven in 1881 in lieu of payment for construction of a new Tomlinson Bridge. The Annex was not completely absorbed into the city of New Haven until 1959. (John H. Koella photograph.)

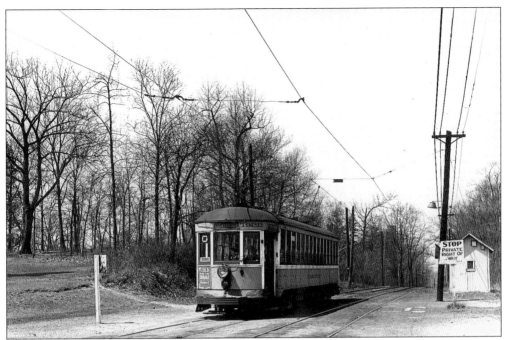

Lighthouse Park–bound car 1922 is shown passing the Townsend Avenue station on Sunday, April 27, 1947. (John H. Koella photograph.)

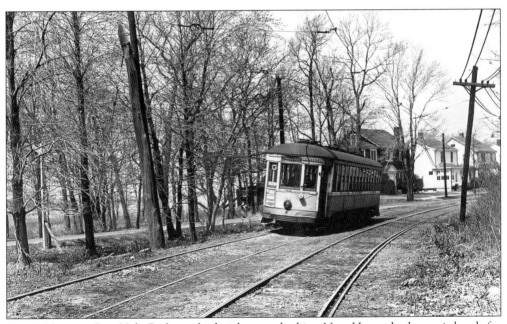

Car 1925 passes Fort Hale Park on the heights overlooking New Haven harbor as it heads for Lighthouse Park on April 27, 1947. This colonial fort, on the site known as Black Rock, had the distinction of being destroyed by the British in 1779 and again in 1781. A third fort was built in 1809. Yet another was constructed in 1863 and named after colonial martyr Nathan Hale. This section of private right-of-way connected Woodward Avenue with Concord Street. (Branford Electric Railway Association collection.)

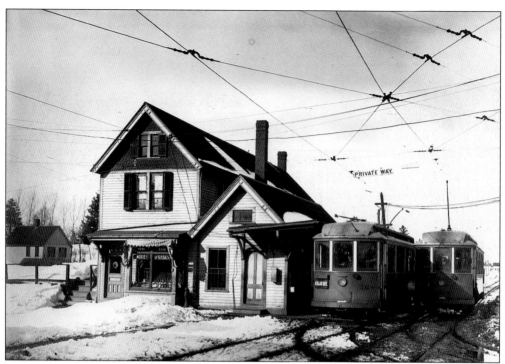

Cars 190 and 195 are shown passing each other at Grannis Corner in 1906. Trolley service to Grannis Corner began in 1893, and an extension to the East Haven green opened one year later. (T. Bronson photograph, George Baehr collection.)

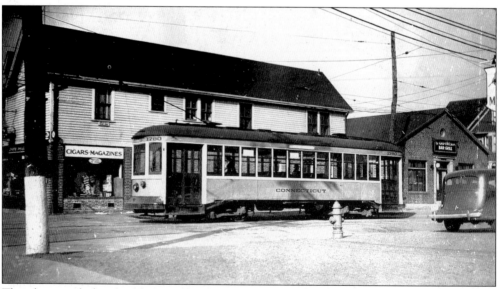

This photograph shows a side view of Lighthouse Park car 1780 on Woodward Avenue at Grannis Corner in 1940. (Harry Hall photograph, Branford Electric Railway Association collection.)

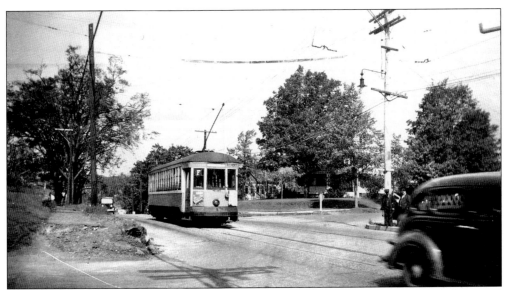

Car 1803 is shown on Main Street in East Haven, passing Bradley Avenue in 1938. (Branford Electric Railway Association collection.)

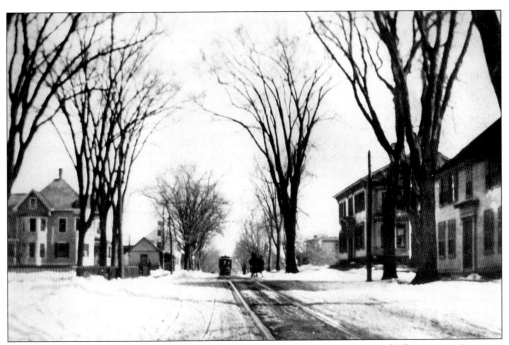

A westbound car from Lake Saltonstall approaches the intersection of Thompson Avenue, High Street, and Main Street in East Haven in 1895. The line was double tracked in 1901. (Branford Electric Railway Association collection.)

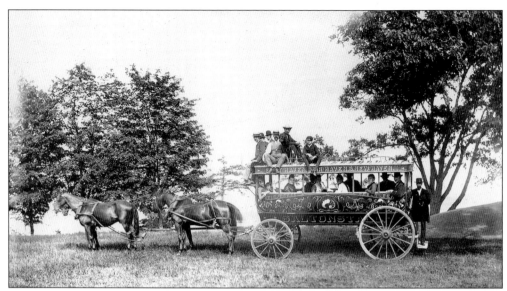

The route description on the Saltonstall omnibus lists some places that are not yet served by streetcars but soon will be. An omnibus this large would have been used to carry a group traveling together to one destination. (Branford Electric Railway Association collection.)

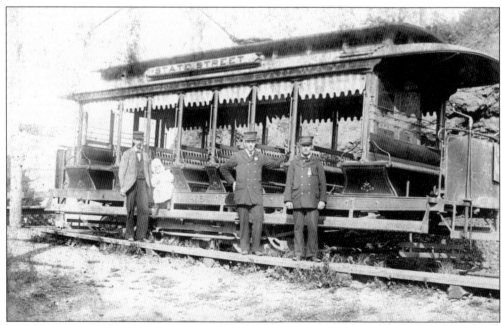

Motorman Fred Ehreth, conductor George Hubbard, and two passengers pose in March 1894 with the first trolley to Lake Saltonstall. When the New Haven Water Company took over the lake two years later, trolley service was discontinued and the recreation area at the lake was replaced by new entertainment facilities at the shore in Momauguin. (Branford Electric Railway Association collection.)

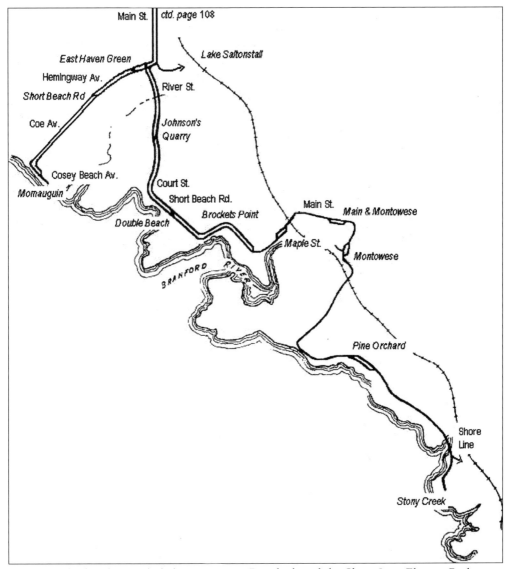

The east suburban line included Momauguin, Branford, and the Shore Line Electric Railway.

ctd. page 108

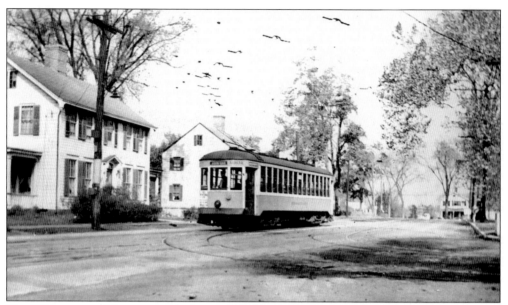

Car 1901, seen on Hemingway Avenue in 1936, is ready to turn onto River Street at the East Haven green and head for Branford. Next to the car is the Stephen Thompson House of 1760. (Branford Electric Railway Association collection.)

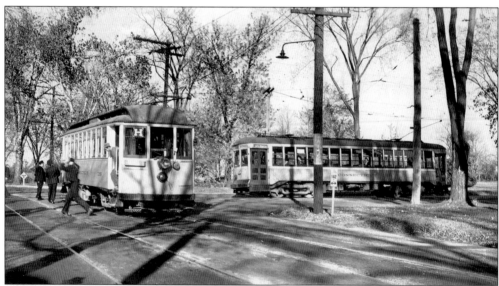

Chartered car 1199 is southbound on the northbound track on Hemingway Avenue at River Street on Sunday, November 3, 1940, heading for the crossover just south of the intersection. The reverse move is necessary to go from the Branford line to Momauguin. Car 1921, on River Street next to East Haven's town green, is the regular service car from Branford to New Haven. (Al Gilcher photograph, Branford Electric Railway Association collection.)

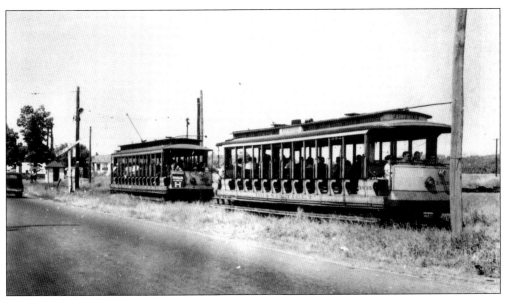

Cars 663 and 1439 stop at the north end of the private right-of-way next to Coe Avenue on the Momauguin line on July 29, 1947. (Jack Beers photograph, George Baehr collection.)

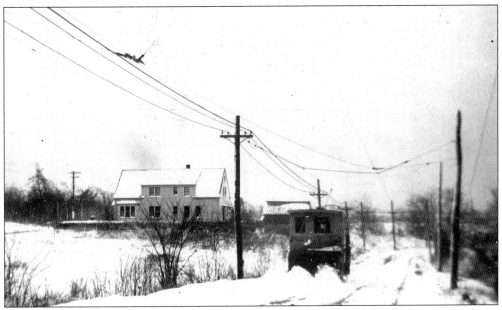

A plow clears the snowdrifts from the Momauguin line private right-of-way. (Branford Electric Railway Association collection.)

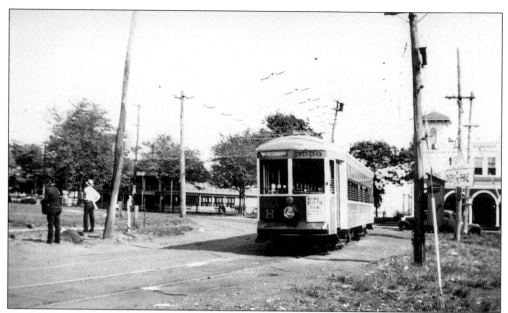

Car 3209 is shown here turning from Coe Avenue onto Cosey Beach Avenue on June 23, 1933. Momauguin was described in tour books of the early 20th century as a "working class amusement park." By 1933, much of the trolley patronage had been siphoned off by automobiles, and the prevailing economic conditions left little money for leisure activities. (William W. Wirtz photograph, George Baehr collection.)

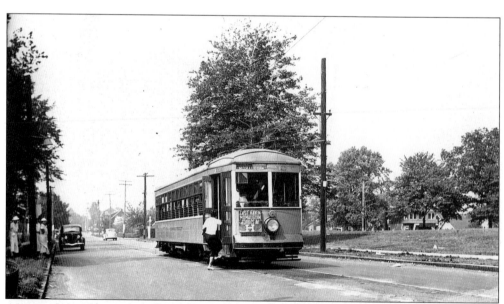

A young lady is shown boarding car 3206 in Momauguin on August 13, 1946. A single-track section replaced the curve into Cosey Beach Avenue when the line was cut back in November 1933. (Branford Electric Railway Association collection.)

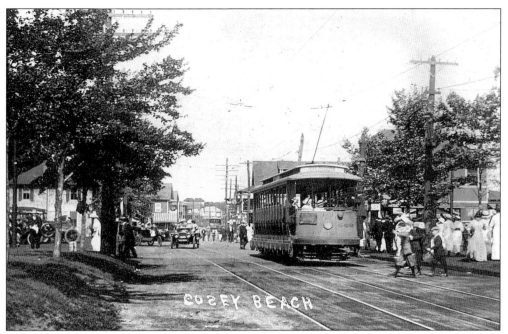

The East Haven River Railway built a two-and-a-quarter-mile trolley line along Hemingway and Coe Avenues from East Haven's town green to Momauguin in 1896. The line was operated by the New Haven Street Railway and was merged into the larger company in 1898. Car 449 is shown on Cosey Beach Avenue east of Coe Avenue sometime between 1911, when it was built, and 1915, when it was renumbered as car 1415. (George Baehr collection.)

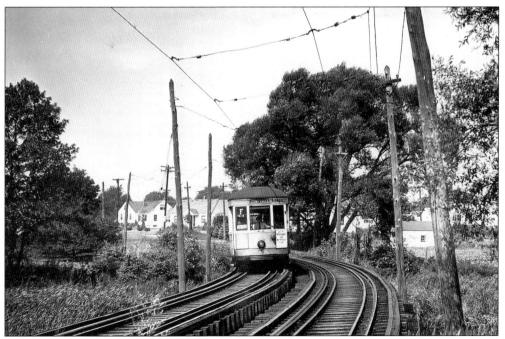

Car 1920 moves from River Street in East Haven onto the trestle over the Farm River and enters the town of Branford. (Branford Electric Railway Association collection.)

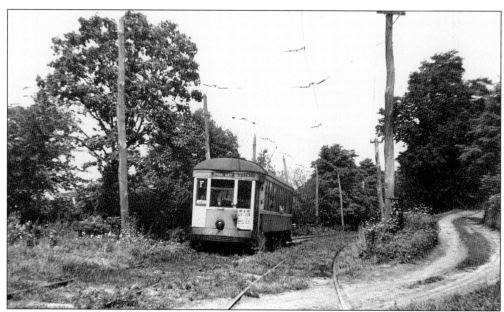

A Branford-bound car is at the Alex-Warfield Road crossing in 1945. (Branford Electric Railway Association collection.)

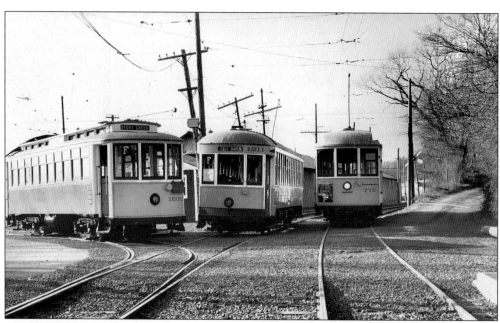

Cars 1602, 1911, and 775 are shown at the Alex-Warfield Road crossing on March 25, 2003. (Denny Pacelli photograph, Branford Electric Railway Association collection.)

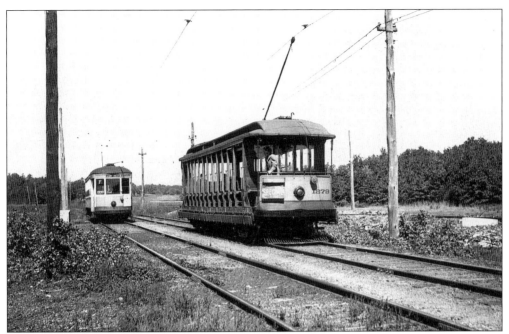

Car 1925 passes open car 1279 on the line across the salt marsh bordering the Farm River in August 1941 just north of the hamlet of Short Beach in the town of Branford. To the right of car 1279 is a siding used by the Connecticut Company to dump ashes, cinders, and other debris into the wetlands. Filling in wetlands is no longer permitted, and streetcars still cross the tidal marsh at this point on the tracks of the Shore Line Trolley Museum. (Branford Electric Railway Association collection.)

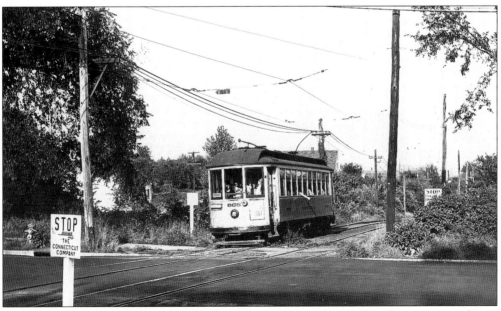

This book was compiled to raise funds for the restoration of car 865 and to maintain the 12 Connecticut Company cars at the Shore Line Trolley Museum. (John H. Koella photograph.)

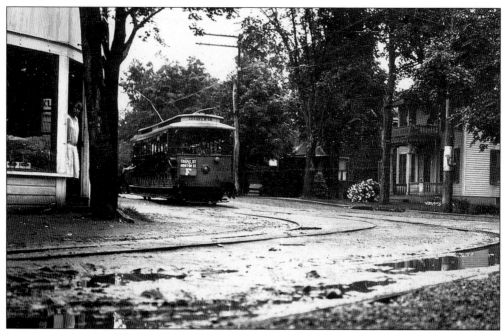

A westbound open car on Main Street (Shore Drive), Short Beach, approaches the corner of Court Street on June 27, 1927. The building on the corner was known as the waiting station, and the name persisted for at least three decades after the streetcars stopped running. (Charles Rufus Harte–Connecticut Company photograph, Branford Electric Railway Association collection.)

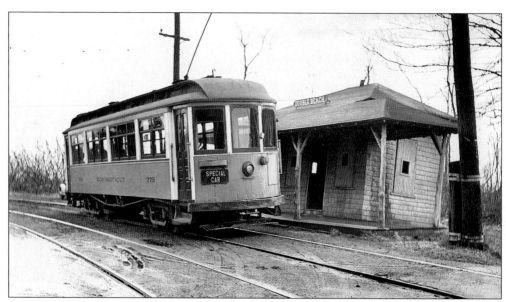

Car 775 is shown at the Double Beach station. This car still operates to nearby Short Beach on the tracks of the Shore Line Trolley Museum. (Don Engel collection.)

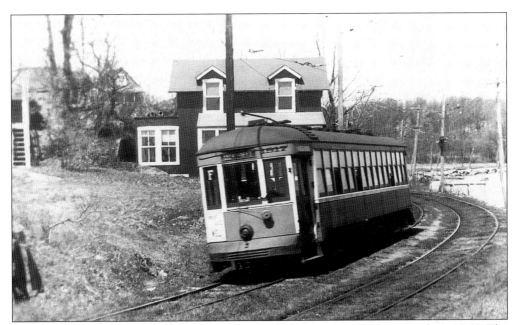

Car 1917 is shown rounding the curve at Brocket's Point in Branford on April 21, 1946. The following day, buses replaced the streetcars east of Short Beach. (Jack Beers photograph, George Baehr collection.)

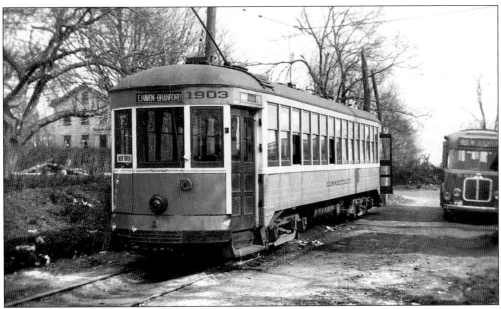

Car 1903 is shown meeting its connection at Stannard Avenue. Each time the Branford line was cut back, replacement bus service was provided from the streetcar terminus to Stony Creek. (Don Engel collection.)

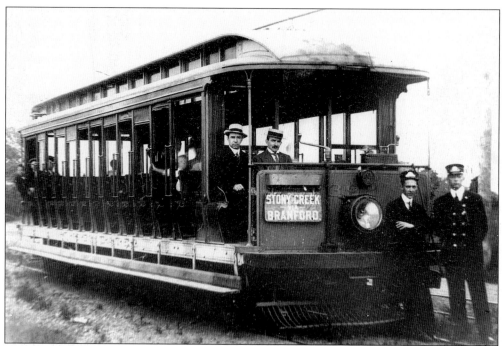

Passenger traffic to Branford consisted largely of travel to the summer colonies along Short Beach Road as well as on the Thimble Islands and in Pine Orchard and Stony Creek. A ride on an open trolley and a respite at the shore were the only way for city dwellers to escape the heat. Consolidated Railway car 392, built by J.M. Jones in 1906, was renumbered as car 414 in 1915. (Branford Electric Railway Association collection.)

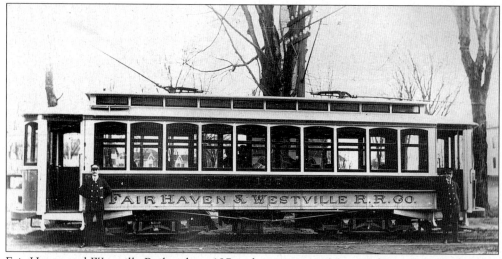

Fair Haven and Westville Railroad car 127 and crew pose at Main and Laurel Streets next to the Branford green *c.* 1901. The Branford line at that time was single-track with passing sidings. On summer evenings, it was common for double-headers and triple-headers to carry the homeward-bound crowds from Branford. On Saturday, July 26, 1902, car 127 and single truck open 145 met head-on on the curve near Johnson's Quarry, with one death and many injuries. Both damaged cars were repaired and returned to service. (Branford Electric Railway Association collection.)

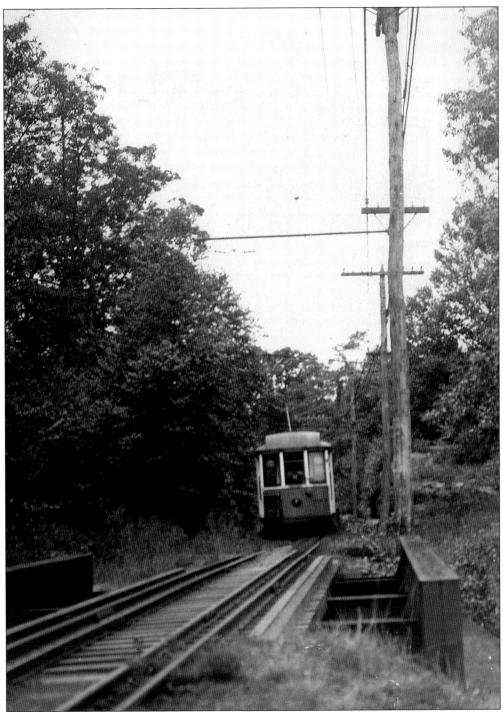

A car on the Branford line crosses the trestle over the Branford Steam Railroad at Pine Orchard on Thursday, September 21, 1933. (Branford Electric Railway Association collection.)

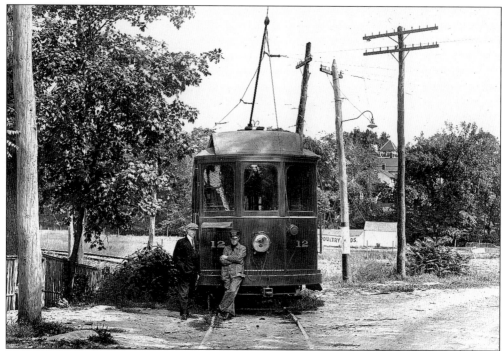

From 1911 to 1919, the Shore Line Electric Railway connected with the Connecticut Company's Branford line in Stony Creek. Shore Line car 12 waits for its connection on Saturday, August 17, 1912, before leaving for Guilford. (Branford Electric Railway Association collection.)

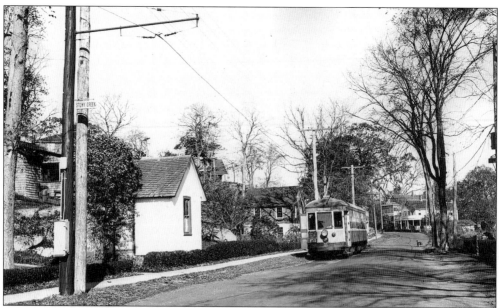

Car 1920 sits at the end of track at Stony Creek, Branford, on Saturday, October 31, 1936. The extension from Branford Center to Stony Creek opened in 1907 and was replaced by bus service on March 1, 1937. (Roger Borrup photograph from George Papuga, George Baehr collection.)